A BRIEF HISTORY OF
MEMPHIS

A BRIEF HISTORY OF

MEMPHIS

G. WAYNE DOWDY

Charleston London

THE
History
PRESS

Published by The History Press
Charleston, SC 29403
www.historypress.net

Copyright © 2011 by G. Wayne Dowdy
All rights reserved

All images courtesy of the Memphis and Shelby County Room, Memphis Public Library and Information Center.

First published 2011

Manufactured in the United States

ISBN 978.1.60949.440.7

Dowdy, G. Wayne.
A brief history of Memphis / G. Wayne Dowdy.
p. cm.
Includes bibliographical references and index.
ISBN 978-1-60949-440-7
1. Memphis (Tenn.)--History. I. Title.
F444.M557D687 2011
976.8'19--dc23
2011036090

For Barbara and Gerald.

CONTENTS

ACKNOWLEDGEMENTS

When I was a boy, my mother, Barbara Ann Nance Dowdy, patiently read aloud to me billboards, books, cereal boxes, movie posters, newspapers, traffic signs and any other printed material that excited my curiosity. It was from her that I developed a fascination with the written word. My father, Gerald McLain Dowdy, always has a story to tell, and it was from him that I first learned the importance of narrative in describing the events of the past. My mother did not live to see this volume completed, but her love is pressed between every page. I dedicate this book to my parents; my grandparents, John McLain and Ivy Lucile Heckle Dowdy and William Herbert and Lurline Belle Griffin Nance; my brother and sister-in-law, William Johnathan "Bud" and Robin Paige Clement Dowdy; my niece, Britney Amber Dowdy; my nephews, Cody Austin Dowdy and Brandon Ryan Dowdy; Uncle J.B. and Aunt Carole Nance; and Uncle Larry H. Nance, Uncle Ron G. and Aunt Donna Nance and Aunt Viola Heckle. Lastly, I also dedicate this to my cousins: Justin, Clay and Clint Nance; Lisa Nance Brooks; Mike, Forrest and Ariana Brooks; Chris, Heather and Haleigh Nance; Gene and Jean Hair Miller; Laura Leigh Miller Traylor; John, Olivia Belle and Conrad Traylor; Eddie, Rachael, Alex and Stuart Miller; Lanie and Martha Miller; Faye Stabler; Kim Hair Sox; Donald, Corey and Luke Sox; W.D. Hair; Wanda and Tate Gattis; and Ann and Harold Waldon.

I also wish to thank my colleagues in the history and social sciences department at the Benjamin L. Hooks Central Library, Betty Blaylock, Joan Cannon, Jeramy Clark, Gina Cordell, Laura Cunningham, Dr. Barbara

D. Flanary, Sarah Frierson, Priscilla Harris, Verjeana Hunt, Dr. James R. Johnson, Thomas W. Jones, Patricia M. LaPointe, Patrick W. O'Daniel, Belmar Toney, Marilyn Umfrees, Ella Walker and Tanjarae Weddle for all their friendship and encouragement over the years. The administration of the Memphis Public Library and Information Center—Director Keenon McCloy, Deputy Director Fred Bannerman-Williams and Central Public Services manager Kay Mill Due—deserve recognition for their strong commitment to our local history collections and their unfailing support of my work.

My fellow Kia Kima Staff members—Peter Abell, Robert Allen, Jim Boksa, Brad Bradley, Peter Budd, Robert Cochran, Alan Gilmer, James Greer, Jeff Hodge, Walter Hoehn, Ken Kimble, Hugh Mallory, Andrew Perry, Paul Prothero, Dave "Truck" Robinson, George R. Smith, Sandy "Stan" Smith, Jason Stewart, Grant Wade, Jim Warr, Otis Warr IV, Carey White and Donald Woodlee—have proven that, despite grave warnings, the Thunderbird will never die. My friend Hugh Higginbotham knows more about Memphis than anyone, and fortunately for me, he never makes a long story short. Ken Kimble also deserves extra thanks for promoting my books to anyone who would listen. I also want to acknowledge Bruce, Darla, Debbie, Debra, Dexter, Evelyn, George, Gloria, Jennifer, Kiki, Mary, Miss Millie, Pam, Shannon, Stacy and Tara at Charles Cavallo's Cupboard Restaurant not only for serving delicious food but also for keeping the spirit of Memphis alive by preserving southern cooking.

I am very fortunate to have two best friends, Gina Cordell and Carey D. White. Gina, along with her husband, Paul Gahn, as well as Carey's wife, Beena, and their children, Natacha, Mischa and Dennis, have all freely given their love and support to me over the years even when I am at my worst.

I also could not have written this book without the friendship of several dear family friends who made the past two years a bit more bearable. Sincere gratitude goes to my future nephew-in-law, Larry Pierce, as well as Bill Agee; Marie Bartnick; Kim Soltis Donovan; Judge Donna Fields; Ramona Hubbard; Jeanetta and Bob Hurt; Eric, Cindy, Carson, Nicholas and Tyler Klein; Ed and Mary McManus; Betty Melendy; Stan Soltis; Judge Bob Weiss; Terry Wells; Dr. Charles and Ann West; and Jo Williams. Finally, The History Press is a wonderful publisher to write for, and I especially owe thanks to Will McKay, Katie Parry and Jamie Barreto for doing such a great job of commissioning, promoting and selling my books.

MEMPHIS'S THREE REVOLUTIONS

No city in the United States provides a historian with a richer tapestry to work with than Memphis. In my previous books, I focused on specific people and events in the Bluff City's past. My first book, *Mayor Crump Don't Like It: Machine Politics in Memphis*, was a biography of E.H. Crump and his political machine that dominated the Bluff City during the first half of the twentieth century. Its sequel, *Crusades for Freedom: Memphis and the Political Transformation of the American South*, traced the momentous changes that swept Memphis and the South between the years 1948 and 1968. *Hidden History of Memphis*, my third book, provided readers with forgotten stories from the Bluff City's past, such as the Boy Scout who uncovered a German spy ring during the First World War and the gangster who inspired one of the twentieth century's greatest novelists.

A Brief History of Memphis is somewhat different from these earlier volumes. Instead of focusing on one notable person or concentrating on a relatively short time span, this book attempts to cover the major events in Memphis history, from its early days as a raucous river town through its emergence as a major southern metropolis in the final decades of the twentieth century. The book also attempts to chronicle the three contributions Memphis made that revolutionized American culture and society.

The most far-reaching of these revolutions was in the field of music, which began with W.C. Handy's blues compositions and culminated with Sam Phillips and Elvis Presley's rock-and-roll and the soul sounds of Stax Records. Although less known than the Memphis sound, there were two

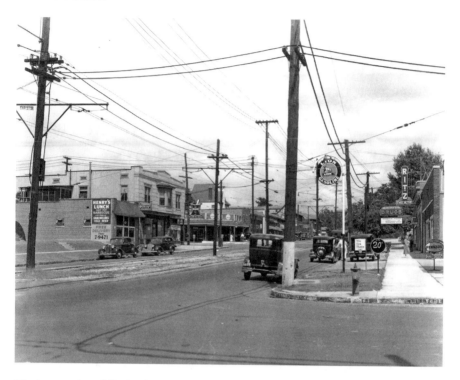

The intersection of Poplar Avenue and Belvedere in the Evergreen neighborhood in about 1935.

other significant innovations that began in the Bluff City and went on to transform the world. Entrepreneurs Clarence Saunders, Kemmons Wilson and Fred Smith forever changed the grocery, motel and shipping industries and, consequently, influenced how Americans shopped, traveled and mailed packages. The third and least known of these revolutions occurred in the political arena. Unlike much of the rest of the South, African Americans voted in Memphis in large numbers. Their votes not only swayed the outcome of elections but also laid the foundation for one of the nation's most powerful political machines and paved the way for the civil rights movement.

Like my other books, *A Brief History of Memphis* is also an attempt to share with others what I have learned from studying and working with historic documents housed in the Memphis Public Library and Information Center's Memphis and Shelby County Room. Hopefully, those who understand something of Memphis's history will find in these pages much that is new to them, while readers unfamiliar with the Bluff City will discover in this book an exciting journey into the past of a great American city.

"TRICK OF THE PROPRIETORS"

In October 1818, elders of the Chickasaw Indian tribe sold more than 6 million acres of land to the United States. Included in the purchase was the Fourth Chickasaw Bluff, which was located on the Mississippi River in what would become the western district of Tennessee. Although the Chickasaw nation technically owned the property until 1818, this did not deter the State of North Carolina from claiming all land between its western boundary and the Mississippi River. Consequently, North Carolina officials gave some Chickasaw tracts to Revolutionary War soldiers and sold other parcels to pay state debts. One such piece of property was the Fourth Chickasaw Bluff, purchased from the State of North Carolina by John Rice. After Rice's death in 1791, his heirs sold the grant to John Overton, who then shared parcels with Andrew Jackson and James Winchester. Despite owning legal title to the land, they could do little with it until the Chickasaw cessation of 1819.

With the sale complete, Jackson, Overton and Winchester wasted little time in organizing their property. Dividing the bluff into lots, the proprietors hoped to increase the area's population through land sales, a stable government and expanded trade. This put them in direct conflict with many of the original settlers, or squatters, who did not own titles to their land and were fearful of being displaced by newer, wealthier arrivals. On November 24, 1819, the Tennessee legislature, acting on the proprietors' wishes, established Shelby County, named for Revolutionary War hero and Kentucky governor Isaac Shelby.

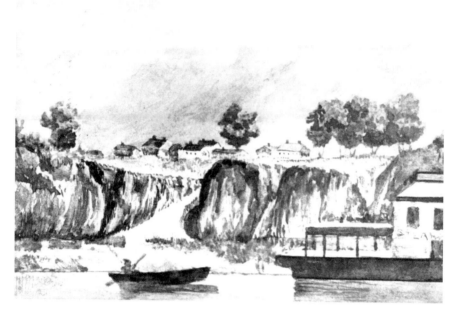

A view of Memphis not long after a German nobleman described the town as "a group of rather miserable houses."

In the spring of 1820, Governor Joseph McMinn appointed six justices of the peace to administer local government in Shelby County. Among this group was James Winchester's son, Marcus, who had arrived at the fourth bluff in 1818 to represent the interests of the proprietors. Born in Sumner County, Tennessee, Marcus Winchester joined the army during the War of 1812, in which he was captured by the British and held in a Canadian prison camp for several months. When Winchester arrived at the bluff, there was little to suggest that the area could become a trading metropolis. During the 1820s, Bernard, Duke of Saxe-Weimar Eisenach, traveled down the Mississippi River and was unimpressed by what he saw.

"Upon the fourth Chickesa [*sic*] Bluff…stands a group of rather miserable houses," the German nobleman wrote in his book *Travels Through North America During the Years 1825 and 1826*. Recognizing the discontent brewing among some of the squatters, and wishing to appease them, the proprietors offered many of them titles to their land. This, however, did not satisfy the most strident member of the anti-proprietors faction, Isaac Rawlings.[1]

Rawlings had lived at the fourth bluff since March 12, 1814, when he was appointed by the federal government to run a trading post in order to "secure the friendship of the Indians in our country in a way the most beneficial and

the most effectual and economical to the United States." The majority of original settlers deeply respected Rawlings for his willingness to arbitrate local disputes and dispense justice without charging fees. In December 1826, when a shipment of Nashville newspapers arrived declaring that the state legislature had incorporated the bluff as the town of Memphis, the squatters turned to Rawlings in hopes that justice would again prevail.[2]

Sharing his neighbors' view that high taxes would be an inevitable result of incorporation, Rawlings organized a public meeting to debate the incorporation charter. Many of the settlers denounced the measure, including one contrary soul who denounced it as a "trick of the proprietors." Rawlings echoed this view when he rose to speak. According to historian O.F. Vedder, Rawlings explained to the audience—proprietors' representatives and settlers alike—that "the town had not grown sufficiently in wealth and population to need a town government, and that its support would be a severe hardship on several of the poor people living in the outskirts of the proposed town." Rawlings's passionate argument convinced the proprietor faction to contract the town's limits and exclude the poorest section of the bluff. This move did not eliminate the threat of taxation, but it nevertheless mollified many of the settlers, who tenuously accepted the new government.

The charter of incorporation created the office of mayor and a board of aldermen, to which was granted:

> *Full power and authority to enact and pass all bylaws and ordinances necessary and proper to preserve that health of the town; prevent [and] remove nuisances and to do all things necessary to be done by corporations; provided, none of the acts or ordinances shall be inconsistent with the laws and constitution of this state.*

Aldermen were chosen by "all persons residing in said town, who are entitled to vote for members of the general assembly," and the mayor was elected by the board of aldermen from within its membership. The first election was held on April 26, 1827, and several residents sought alderman positions, including Marcus Winchester. There was one notable absence on the list of candidates, however. Still smarting over the charter controversy, Isaac Rawlings refused to allow his name to be put in contention. N.B. Attwood, Joseph L. Davis, John R. Dougherty, G. Franklin Graham, John Hook and William D. Neely along with Winchester were chosen to serve as alderman; at the first meeting, Marcus Winchester was selected mayor.[3]

Once the mayor had been chosen, the major issue facing the aldermen was how to pay for the newly installed government. Taxes were assessed on property owners with improved lots, while peddlers, tavern keepers, physicians and attorneys paid a business levy for operating in the town. In addition, each free male inhabitant and slave were levied a twenty-five-cent tax for residing in Memphis. The first government also fixed the boundaries of the town and appropriated funds for street improvement. Reelected mayor the following year, Winchester oversaw the construction of a wharf that increased river traffic, expanded the town's population and provided additional tax revenue in the form of wharfage fees. In his two years as mayor, Winchester effectively implemented the proprietors' vision for Memphis; taxation led to street improvements and wharf construction, which in turn increased the town's population and established it as a trading center. Indeed, by 1829, so much mail was passing through town that the U.S. Postal Department granted Memphis the same status as Nashville, which prompted the legislature to recognize the municipality as Tennessee's second major town. This was no doubt gratifying to Winchester, but it also signaled

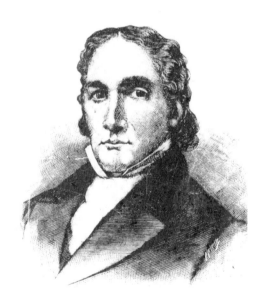

Isaac Rawlings originally opposed the proprietors' plans for the city but was later elected the second mayor of Memphis.

the end of his public career. He had been serving as postmaster in addition to mayor, but the upgraded postal status forbade the local postmaster from holding other public office. Reluctantly, Winchester announced on the eve of the next scheduled election that he would not seek a third mayoral term.

By 1829, Isaac Rawlings had reconsidered his decision to avoid involvement in local government. Consequently, he ran for, and won, a seat on the board of aldermen in the March 1829 town election. A vote was held at its first meeting, and Rawlings was selected mayor by a vote of four to three. As mayor, he

abandoned the squatters and instead continued Winchester's policies by improving streets and dividing the town into three wards, which expanded the size of the board of aldermen. Although reelected in 1830 and 1831, there were some in Memphis who never forgave Rawlings for switching sides and championing the proprietors' cause.

In response, Rawlings attempted to eradicate the squalid neighborhood called Catfish Bay, located at the mouth of Gayoso Bayou. Labeling the neighborhood an "insufferable nuisance," the aldermen introduced an ordinance to depopulate the area that Rawlings supported. Catfish Bay denizens, joined by newly arrived Irish immigrants living in the equally poor neighborhood known as the Pinch, denounced the nuisance ordinance as "a cruel, tyrannical infraction of the poor man's rights, and a violation of the Constitution." Ably assisting them in their fight with the aldermen was attorney Seth Wheatley, who successfully lobbied a majority to scrap the ordinance.[4]

The widespread support Wheatley received from Catfish Bay convinced the young lawyer to challenge Isaac Rawlings for an alderman seat. In March 1831, citizens from the impoverished neighborhoods flocked to the polls, where they repudiated Isaac Rawlings and elected Wheatley in his stead. When Rawlings learned that his former colleagues had chosen Wheatley as the next mayor, he allegedly determined to seek revenge on those who cost him his office. Two nights after the election, a boat filled with animal waste mysteriously floated into Catfish Bay and overturned. The stench emanating from the rancid waters soon turned the stomachs of the residents and forced them to flee.

Wheatley served only one term as mayor, as did Robert Lawrence, who was elected in March 1832. Soon after Lawrence's selection, a census was taken that revealed that the population of Memphis had increased to 906 people. Recognizing this increase, the legislature expanded the town limits in October 1832. Many voters apparently longed for stronger leadership than Wheatley or Lawrence provided because in the municipal election of 1833, Isaac Rawlings was again elected to the board of aldermen and selected mayor. Reelected two more times, during his three additional terms Rawlings purchased a fire engine, which greatly improved the safety of Memphis.[5]

In addition to the fire engine, another expansion of town services came during the second administration of Mayor Enoch Banks, who served two nonconsecutive terms, 1836–37 and 1838–39. In August 1838, a board of health was appointed to "report to town constable all causes of disease the require removal and to arrange for the printing of death notices giving cause, name, and address in each instance." The mayor who served between

Banks's two terms, John H. Morgan, also attempted to improve conditions in Memphis. During Morgan's one-year term, the board of aldermen passed an ordinance requiring the operators of dray wagons to obtain a license for ten dollars per year, and if a driver was found guilty of "stealing or of having received stolen goods, he shall forfeit license and be thereafter prohibited from driving a cart, dray, or wagon within corporate limits." A few months later, the aldermen passed a more stringent law that imposed "a penalty on persons shooting, whooping, gambling or swearing within the limits" of the town. Fines ranged from five dollars for swearing to ten dollars for discharging a firearm and fifty dollars for gambling—fees were doubled if the offense occurred on a Sunday.

Mayor Thomas Dixon, elected in 1839, expanded the anti-crime measures implemented by Morgan. Realizing that the constable could not patrol the town twenty-four hours a day, the board of aldermen hired two night watchmen, who were each paid $400 a year to patrol the town's streets from 10:00 p.m. to daylight. Night watchmen had the authority to detain "disorderly" people, who could be fined for their offense, and compel any citizen to help them enforce the law. The aldermen also took steps to control the growing number of free persons of color and slaves living in, and navigating through, Memphis. Any African American, whether free or slave, who was discovered on the streets after 10:00 p.m. was automatically thrown in jail until morning. Detained slaves were then given ten lashes and their owners fined two dollars, while free blacks were fined ten dollars.[6]

Dixon and the aldermen also passed an ordinance requiring dog owners to buy a license and place an identification collar around the canine's neck. If a dog was found without a collar, it would be summarily shot by the town constable. The town also purchased a larger fire engine, which could discharge 220 gallons of water per minute. Perhaps more importantly, on April 25, 1840, Dixon proposed an act to remove the town designation and adopt the name "City of Memphis," which was supported by the aldermen. Despite Dixon's considerable accomplishments in fighting crime and expanding city services, he was defeated for reelection by William Spickernagle in the spring of 1841.

For the first fifteen years of its existence, the office of mayor had few powers, was controlled by the board of aldermen and did not even pay a salary. This changed when the voters of Memphis ratified a proposal to pay the mayor $500 per year for his services, and the city's charter was amended to allow for the direct election of the mayor. The awarding of a salary and bringing the office out from under the aldermen's control provided Mayor

Spickernagle with added influence, which he used to address perhaps the greatest problem facing Memphis government.

For many years, flatboat operators had refused to pay city fees when they docked at the city-operated wharf. A raucous and violent-prone lot under the best of circumstances, the river men violated local laws with impunity and were not shy about spreading terror through the streets of Memphis. Their refusal to pay severely restricted the ability of local government to provide services and implement needed improvements. One reason for this deplorable situation was the timidity of earlier wharf masters, who all too often knuckled under to the flatboat men. Determined to remedy this, Spickernagle hired James Dick Davis, a local painter and future Memphis historian, to serve as wharf master, offering him "twenty-five per cent of his collections and promised to stand by and sustain him." In order to strengthen Davis's hand, the mayor also formed two armed militia units to enforce the wharf master's decrees. As a result of Spickernagle's actions, wharfage fees soon filled the city's treasury for the first time in years. So while the city treasurer counted the funds, the flatboat men seethed with rage over a measure they believed to be "onconstitutional."[7]

Feelings of rage turned violent two months after Edwin Hickman defeated Spickernagle in the March 1842 municipal election. On a very hectic collection day in early spring, five hundred flatboats were docked at the wharf. As the day wore on, an irate boat owner named Trester brandished a spiked club and threatened to "comb the Memphis wharf master's head." When Davis arrived on the scene, Trester waved the cudgel in his face and loudly declared, "I cut this on purpose for you, and I am going to use it on you if you ever show your face here while I remain…I am the master of the landing." As Trester's rant reached its climax, Davis noticed that a large crowd had formed and was lustily cheering the boat owner's defiance. Fearing for his safety, Davis left the wharf and met with Mayor Hickman, who issued a warrant for Trester's arrest and ordered Constable G.B. Locke to serve it.

When Locke attempted to serve the document, Trester threatened him as well, so the constable turned to the militia. Captain E.F. Ruth and a dozen armed militiamen quickly dispersed the crowd as Trester and his crew hastily paddled their boats away from the wharf. Safe in the belief that he had escaped their wrath, the boat owner taunted the militia to open fire on him. Davis, Constable Locke, Captain Ruth and the armed volunteers boarded the city's ferry and rowed toward Trester. Members of the military company watched as Davis, Locke and Ruth were clubbed to the deck as soon as they

boarded Trester's vessel. Enraged by what they saw, the volunteers opened fire, killing Trester immediately. Upon returning to the shore, a mob of armed boatmen swarmed the wharf area, but the crowd dispersed when met by equally armed citizens and militia. The decisive action taken by Mayor Hickman, Wharf Master Davis, Constable Locke and Captain Ruth broke the power of the flatboat men and secured an important revenue stream for the city, which improved dramatically the city's overall economy.[8]

In 1841, during Spickernagle's term, Congress appointed a commission to investigate and recommend a site for a freshwater naval yard somewhere in the Mississippi Valley. When the mayor and aldermen learned of this effort, they appointed their own committee to "draw up a memorial to the president of the United States, setting forth the claims of Memphis and the advantages she possesses for such an establishment." It is not known whether this document had any effect on the subsequent choice, but the federal commission determined, after a tour of the Mississippi Valley, that the best location for the proposed naval yard was in Memphis at the mouth of the Wolf River. Mayor Hickman and the board of aldermen agreed to sell the property to the federal government for $25,000 on May 4, 1843, and the parcel was transferred to the federal government the following year. Although the navy yard never reached its potential and was abandoned in the early 1850s, nevertheless it drew attention to the economic potential of Memphis and the lower Mississippi Valley.

This became apparent in November 1845 when the city hosted the Southern and Western Commercial Convention eight months after Jesse Johnson Finley was elected mayor. Designed to advocate for the construction of public works such as roads, canals and railroads to improve the economy of the southern and western states, the convention was attended by 476 delegates from fifteen states. The highlight of the gathering was an address by former vice president John C. Calhoun of South Carolina, who urged the convention to pressure the federal government to improve navigation on the Mississippi because "congress has as undoubted a right as to protect and provide for the safety of our commerce on the ocean." Despite its earnestness, the convention did not see any of its proposals come to fruition for the region. However, the delegates were able to lay the foundation for a railroad to be constructed between the Atlantic Ocean and the Mississippi River, which would have a profound effect on the future economy of the Bluff City.

Between 1846 and 1848, two former mayors, Edwin Hickman and Enoch Banks, returned to office for one term each. Banks again ran for reelection on March 4, 1848, but he and his opponent, Gardner B.

Locke, each received 356 votes, which required the board of aldermen to choose the next mayor. After two ballots, Locke was chosen the new city executive. Within a few weeks of his selection, Locke convinced the aldermen to pass an ordinance establishing free public schools in Memphis. J.W.A. Pettit was named superintendent, and schools were quickly opened in the second and third wards of the city. By the summer of 1848, however, opposition arose over the continued funding of the schools. An ordinance was introduced calling for the "discontinuance of the ward schools." The proposal was quickly rejected, and Locke and the pro-schools faction introduced a comprehensive bill designed to secure the continuation of public education in Memphis. Passed on June 19, 1848, the ordinance guaranteed that all white children between the ages of six and sixteen had equal opportunity to attend a free public school. The city was divided into two school districts governed by a board of managers made up of the mayor, two aldermen and one citizen from each school district. To pay for the schools, the law established a levy taken from one-eighth of the city's annual revenue.

The opposition to public education undoubtedly played a major role in the outcome of the 1849 municipal election. Mayor Locke sought reelection but was defeated by the perennial candidate Enoch Banks. During Banks's final term as mayor, Memphis was merged with the nearby town of South Memphis, which increased the size of the city and provided additional tax revenue for local government. The annexation, however, did little for Banks's political fortunes. His public life came to a sudden end when he lost to Edwin Hickman in the 1850 city election. When Hickman resumed his mayoral duties, he remained a dedicated foe of crime, as befitting the executive who had crushed the flatboat insurrection. Ordinances were passed making gambling, organized prostitution and animal cruelty illegal, requiring that businesses close on Sundays and levying a fine against anyone found disturbing a religious service.

During Hickman's final mayoralty, which lasted until 1852, Memphis voters overwhelmingly approved a referendum authorizing the board of aldermen to purchase $500,000 worth of stock in the Memphis and Charleston Railroad then in the formative stages of its construction. Meanwhile, the additional population from South Memphis shifted the balance of local politics and led to the mayoral election of former South Memphis executive A.B. Taylor. Serving until 1855, Taylor established a city high school, constructed a new jail and improved local transportation by having wooden planks laid on the surface of Adams and Madison

Streets. A public health ordinance was also passed during the Taylor era that authorized the city hospital to treat destitute Memphians who could not afford medical treatment.

Public health was also of grave concern to Taylor's successor, A.H. Douglass, who was elected in July 1855. During that hot summer, the yellow fever disease spread through the Lower Mississippi Valley, infecting more than 1,200 Memphians and killing 220 of them. During Douglass's one-year term, Memphis also issued a number of bond issues for railroads and street construction, which added a considerable financial burden to the city treasury. By the end of the 1850s, municipal debt ballooned to more than $1 million. At the same time, wasteful practices and the misuse of public funds further weakened the city treasury. The combination of poor public health and financial instability would have a singular effect on the Bluff City in the decades to come. In July 1856, Thomas B. Carroll, the son of former Tennessee governor William Carroll, was elected mayor but died unexpectedly at the age of thirty-eight in April 1857.

The Memphis and Charleston Railroad, completed in 1857, linked the Mississippi River with the Atlantic Ocean.

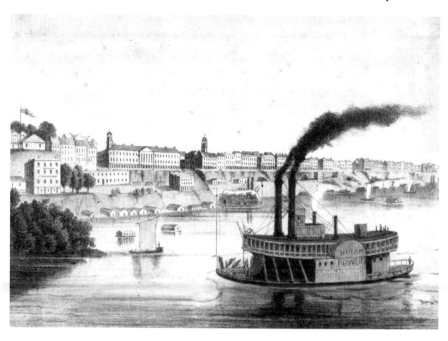

During the 1850s, Memphis's economy boomed as thousands of pounds of cotton were shipped from the city and several manufacturing concerns were opened.

Carroll's death came a few weeks after the lines for the Memphis and Charleston Railroad were completed on March 27, 1857. A Grand Railroad Jubilee was organized to celebrate the "wedding" of the Atlantic Ocean and Mississippi River. Thousands of revelers poured into the city on May 1 and 2 to partake of the festivities, so many that a newspaper reporter from St. Louis had to share a hotel room with fourteen other people. Overseeing the celebration was A.H. Douglass, who had been drafted by the board of aldermen to complete Mayor Carroll's unexpired term. Delegations from many southern states traveled to Memphis, including the fire department of Charleston, which brought ocean water to pour into the Mississippi. A parade of governors, War of 1812 veterans and visiting local politicians opened the celebration, which was viewed by thirty thousand spectators. After several long-winded speeches delivered at Court Square, the Charleston firefighters "threw into the swift current of the Mississippi a crystal stream from the Atlantic's bosom." As the crowd roared, a long table was set up in the old navy yard property for a banquet—ten thousand people feasted on 400 chickens, 125 turkeys, 75 hams, two thousand pounds of beef and five hundred pounds of cake. After gorging themselves, the people in the crowd were treated to a large fireworks display that brought festivities to a climax.

As Memphians went back to their homes, they had much to be proud of. When their government was established in 1826, Memphis consisted of a handful of "miserable houses" inhabited by a mere three hundred people. By the late 1850s, much had changed. Its population had risen to twenty-two thousand residents and included, in the words of historian Gerald Capers, "bankers and manufacturers, cotton buyers and factors, wholesale grocers and slave traders, doctors and lawyers, editors and railroad presidents." During 1858 and 1859, 323,097 bales of cotton were shipped from Memphis, fulfilling the proprietors' hopes that Memphis would become a major southern trading center. In addition, industrial manufacturing took hold in the Bluff City during the third decade of its existence. By 1860, companies were producing boots and shoes, bricks, carriages, cottonseed oil, doors and sashes, flour and corn meal, lumber and steam engines in Memphis.[9] As the 1850s came to an end, Memphis could not escape the growing political crisis over slavery and states' rights that not only threatened to engulf the nation in civil war but also menaced the hard-won economic gains that Memphis had achieved during its first twenty-five years.

"THE UTTER FAILURE OF THE MUNICIPAL GOVERNMENT OF MEMPHIS"

The economic success achieved in the 1850s simply could not have been accomplished without the backbreaking labor of enslaved human beings. African American slaves picked the cotton that was shipped through the Bluff City and worked the docks that loaded the white gold onto steamboats. Slaves also constructed railroads and worked in many of the city's manufacturing concerns. In addition, the buying and selling of slaves was also one of the most lucrative businesses in Memphis. For example, the slave-trading firm owned by city alderman Nathan Bedford Forrest charged between $800 and $1,000 for individual chattel, and in a good year, Forrest and his partner, Byrd Hill, sold more than 1,000 slaves. By 1860 there were 16,953 slaves residing in Shelby County, and the majority of them made their way into Memphis either through the cotton trade or being rented to businesses in the city. Because of Memphis's dependence on cotton and slaves for its economic growth, the city was often referred to as "the Charleston of the West."

The large numbers of slaves passing through the city made government officials very nervous. As a result, the mayor and board of aldermen passed several ordinances designed to control the number of slaves and free persons of color who resided or worked in Memphis. On March 27, 1850, an omnibus bill was passed that severely restricted the movements of African Americans in Memphis:

> *State laws against slaves, free blacks and mulattoes to be enforced by city marshal.*

Slaves not allowed to be entertained or permitted to visit or remain on Sabbath in the house of any free person of colour.

Large collection of slaves banned, except for public worship conducted in an orderly manner under superintendence of a white person.

Unlawful for slaves to remain in corporate limits of city after sun set or any part of the Sabbath, except by permission of owner specifying limit of time.

Collection of negroes in tippling houses [saloons and bars] *not to be allowed.*

In 1854, the alderman passed another ordinance granting a reward for anyone, including police officers, who captured a runaway slave. Many white Memphians shared with their fellow southerners the belief that radical northern abolitionists were scheming to destroy the institution of slavery in order to fatally weaken the region's considerable influence over the nation's economic and political life. The majority of whites hoped that the Democratic Party could, in Capers's opinion, "safeguard southern interests within the Union." But not everyone had faith in the Democratic Party. As one fire-eating Memphis newspaper editor wrote: "If in the struggle to preserve our constitutional rights in the union dissolution should come, we say let it come."[10]

Despite Memphis's preoccupation with the growing sectional conflict, the moderate pace of reform continued under the administration of R.D. Baugh, who was elected mayor in July 1857. Baugh and the board of aldermen bought a steam-powered fire engine and organized a professionally paid fire department. A charity hospital was established, and the city paved many of its streets with cobblestones. These expenditures further weakened the city's tottering financial structure, a fact that deeply troubled many of the aldermen. In 1860, Alderman Ayers P. Merrill proposed an ordinance to create a city comptroller to "examine and adjust all accounts and claims against the city." In addition, the comptroller was charged with signing all appropriations, keeping accurate records and auditing the accounts of every city department once a month.

Believing that the proposed bill weakened the powers of the mayor, Baugh vetoed the measure, but the aldermen quickly overrode his action. In the wake of the veto override, an anti-Baugh faction emerged on the board determined to punish the mayor's recalcitrance. When Baugh reluctantly bowed to the will of the board and nominated William O. Lofland to the comptroller position, five aldermen voted against the mayor's nominee and instead proposed an alternative candidate: William L. Lawrence. The city

charter granted the mayor sole power to nominate city officials, but this meant nothing to the anti-Baugh faction. For several meetings, neither side could secure a majority of votes, and when it finally appeared that the mayor would prevail, two aldermen fled the chamber, preventing a quorum, which forced the meeting to adjourn.

The anti-mayoral coalition members eventually allowed Lofland's appointment, but for the rest of his administration, they sniped at Mayor Baugh at every turn. This bickering had disastrous consequences for Mayor Baugh's political future. In the June 1861 municipal election, Baugh and several aldermen were defeated, and John Park was elected mayor. In his inaugural address to the board of aldermen, Park declared: "In view of the embarrassed [*sic*] financial condition of Memphis, you will clearly see that a most rigid system of economy must be observed...Improvements of all kinds must be suspended." However, there were far graver concerns than the impoverished state of the city treasury.

The sectional conflict that had been simmering for a decade reached its boiling point during the 1860 presidential contest. To many large plantation owners, and their poorer white neighbors, the Republican Party was controlled by abolitionists who were determined to destroy slavery and leave the South in ruins. This was not quite true; Republicans were opposed to the extension of slavery into western territories, but they did not publicly call for its eradication. "That the normal condition of all territory of the United States is that of freedom...we deny the authority of Congress, of a territorial legislature, or of any individuals, to give legal existence to slavery in any territory of the United States," declared the 1860 Republican platform. This distinction mattered little to the planter class, members of which were committed to their slave economy even up to the destruction of Constitutional government. When the Republicans nominated Illinois lawyer Abraham Lincoln, who had decried the "nationalization of bondage," many white southerners vowed secession from the Union if the "Black Republican" nominee secured the presidency.

However, most white Memphians were not prepared to go that far. Instead, they continued to have faith in the Democratic Party and its pro-Union nominee, Stephen Douglas. In late October, Douglas visited the Bluff City during a campaign swing through the South. On the day of his speech, October 25, a large procession gathered at the Gayoso House to escort the nominee to Market Square for his address. Two bandwagons playing music, and forty marshals and five hundred people on horseback followed Douglas's

carriage through the streets of Memphis. Thirty-thousand people thronged Market Square to hear Douglas proclaim:

> *I do not come to solicit your suffrages, but to make an appeal in behalf of the glorious Union by an exposition of those principles, which, in my opinion, can only preserve the peace of this country…So long as we live under a Constitution which is the supreme law of all the States of this Union, it should be so construed and executed as to do exact and equal justice to every State and every citizen…This principle of equality not only extends to the citizens of the states, but is equally to be enjoyed by all the citizens of the United States in the common Territories. The citizen of each and all of the States may move into the Territories and carry their property with them on terms of exact equality, no matter whether that property consists in cattle and horses, in merchandise or in slaves, or in any other species of property.*

When the votes were tallied, the two pro-Union candidates, Douglas and John Bell of Tennessee, received 2,319 and 2,250, respectively, while a mere 572 ballots were cast for the secessionist candidate, John C. Breckinridge. Lincoln received no support in Shelby County but did win the presidency.[11]

Memphians accepted the news of Lincoln's election calmly and did not rush to leave the Union. "Let every man put his foot on disunion, it is no remedy for southern wrong…it is only the madman's remedy," wrote one local journalist. However, a secessionist movement did slowly begin to emerge in Memphis after South Carolina fled the Union in December 1860. Secessionist and pro-Union rallies were held throughout Memphis as each faction tried to seize control of the city. One of the largest secessionist rallies took place on January 30 at the Exchange Building. During the well-attended meeting, state senator R.G. Payne did not mince words as to who he believed was responsible for the sectional crisis. The president-elect "held to the odious doctrine of negro equality, was the advocate of negro suffrage and favored the obliteration of all legal distinctions between the black and the white man." Mayor Baugh attended the gathering and was in full accord with Payne and the other pro-secession speakers.

Meanwhile in Nashville, Governor (and former Memphian) Isham G. Harris called the General Assembly into special session to discuss what course to take. After some debate, the legislature scheduled a statewide referendum for voters to decide whether or not a secession convention should be held.

"The Utter Failure of the Municipal Government of Memphis"

A majority of Memphians voted for the proposal, but the rest of Tennessee soundly rejected the measure. That Memphians were conflicted over the issue was confirmed when a majority of voters cast ballots for unionist delegates to the abortive convention. Secessionist sentiment hardened in the spring of 1861 after Lincoln's inauguration, the Confederate attack upon Fort Sumter and the president's call for volunteers to oppose the insurrection. Militia units were formed, the board of aldermen passed a resolution allocating $59,000 for Memphis's defense and a wall of cotton bales was placed at the riverfront to protect the city from attack. An armory was also established to house cannons, rifles and ammunition, and additional police were hired to guard the storehouse. Governor Harris refused the president's request for troops and called the General Assembly into a second special session, in which it declared Tennessee's independence and created a fifty-five-thousand-man army.

On June 8, 1861, a second referendum was held in which the citizens of Tennessee ratified the legislature's action by voting to secede from the United States. Three weeks later, the Tennessee republic joined the Confederate States of America. Mayor Park was elected just after Tennessee left the Union, and in his inaugural address, he echoed the views of many white Memphians when he explained that "there was no alternative left for the South but to withdraw from a Union that instead of affording peace and protection as was originally contemplated, was to be used as a means of destroying all that was valuable to the South." Military matters took precedence over civil affairs, but the mayor and board of aldermen continued to oversee local government as Confederate forces dealt with a series of disasters that threatened their control of the Bluff City.

In the spring of 1862, Union forces under the command of General Ulysses S. Grant invaded the Volunteer State, capturing the strategically important Forts Henry and Donelson in west Tennessee and seizing Island No. 10 on the Mississippi River. In addition, the Federals defeated Confederate forces at the Battle of Shiloh. As these setbacks were occurring, the Confederate general commanding the Army of Mississippi, Braxton Bragg, suspended local government in Memphis and declared martial law in order to quell possible civil disturbances because of the deteriorating military situation. The mayor and board continued to meet under the nominal direction of civil governor and provost marshal B.D. McKissick, but the police department was dissolved in favor of military guards. When a large Confederate force withdrew from Corinth, Mississippi, in late May, troops garrisoned in Memphis and Fort

Pillow, located on the eastern edge of the Mississippi River above the city, also abandoned the region. As the last Confederate troops fled Memphis, city government quickly reformed the police department.

Other than the police, this left only a handful of Confederate gunboats to defend the city. On the morning of June 6, a Federal armada met the Confederate fleet at Memphis, crushing it after an hour-long battle. As Memphians watched in dismay at the burning Southern navy, Union flag officer C.E. Davis sent a message to Mayor Park demanding the surrender of Memphis. Bowing to the inevitable, Park replied: "Your note of this date is received and contents noted. In reply I have only to say that as the civil authorities have no means of defense, by the forces of circumstances the city is in your hands." Colonel G.N. Fitch and a brigade of Indiana infantry then took possession of Memphis "in the name of the government of the United States, for asserting the supremacy of the Constitution and laws of the Union, and restoring peace, protecting public and private property and the lives of citizens."[12]

The occupying force required Park, the board of aldermen and police officers to swear allegiance to the government of the United States or forfeit their posts. This they did, but it was not as easy for Union officials to secure the loyalty of the citizenry. Martial law was declared on June 13, and Special Order No. 1 was issued, which required all Memphians traveling out of the city to first secure a pass from the Union provost marshal and swear allegiance to the United States. The order also promised not to hamper any Memphian engaged in "legitimate business." Several other orders were issued banning the use of Confederate currency, prohibiting the sale of alcohol and requiring all closed businesses to reopen. These orders were promptly ignored, while hundreds of Memphians refused to take the oath. As this passive resistance

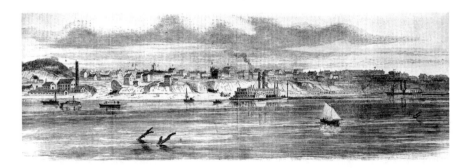

On June 6, 1862, Confederate Memphis fell to Union forces after an hour-long naval battle was fought on the Mississippi River.

was taking shape, Confederate partisans attacked the city's suburban areas, harassing anyone who cooperated with the Union army.

This situation was of grave concern to the Union commander of the West Tennessee District, Major General U.S. Grant, who arrived in Memphis on June 23. Writing shortly after setting up his headquarters, Grant described the city as being in "bad order," with "secessionists governing much in their own way." Grant's arrival coincided with a municipal election, scheduled for June 26. The commanding general allowed the election to take place but required voters to swear the oath before casting ballots. As a result, only seven hundred citizens registered to vote. John Park was reelected mayor without opposition, receiving 698 votes. Several citizens protested the election, claiming that the oath of allegiance requirement violated the city charter and state constitution. Mayor Park sought the advice of a local attorney, who argued that the election was irregular but that only a court could declare the election null and void, not the board of aldermen. This settled the matter for the complainants, who did not seek further legal redress. With his position secured, Mayor Park again turned his attention to the city's debt. Shortly after the election, he addressed the aldermen and urged them to proceed carefully before they adopted "any measure which is to involve the expenditure of money or credit."

Meanwhile, General Grant continued his policy of crushing pro-Confederate sentiment in Memphis and west Tennessee. Orders were issued seizing the property of pro-Confederate sympathizers to pay for the destructive acts of local partisans, who were "not entitled to the treatment of prisoners of war when caught, and will not receive such treatment," which meant in practical terms that they were subject to immediate execution. Union officials also made the display of Confederate symbols a crime, ordered all persons connected with the Confederacy to leave Memphis and later required all white men between the ages of eighteen and forty-five to take the oath of allegiance or leave the city.

On July 16, Grant was ordered to assume command of all Union troops between the Mississippi and Tennessee Rivers, which necessitated his move to Corinth, Mississippi. Four days later, on July 19, Grant's Shiloh partner, William T. Sherman, assumed command of Memphis and the West Tennessee District. At first, Sherman tried to cooperate with civil officials in order to mollify the citizenry. In a letter to Mayor Park, the Union general declared: "I have the most unbounded respect for the civil law courts and authorities and shall do all in my power to restore them to their proper use viz: the protection of life and property." Sherman urged the mayor and

aldermen to maintain a strong police force but promised that the provost guard would assist law enforcement when needed. Despite his conciliatory rhetoric and policies, Sherman took pains to remind local government that "for the time being the military must be superior to the civil authority."

With native businesses refusing to open, two hundred merchants from Cincinnati and Louisville floated down the river to the Bluff City with a large cache of supplies that soon stocked the shelves of newly opened stores. Wanting the retail establishments to continue operating, Sherman issued orders allowing goods to be shipped between Memphis and the countryside without military passes. Almost overnight, the local economy blossomed to a degree not seen in peacetime. As one observer reported, the current Memphis "had little resemblance to the city of two years previous." Sherman's decision, however, had unintended consequences for the Union occupation. With the roads out of Memphis open, enterprising smugglers prolonged the conflict by shipping tons of valuable supplies to the beleaguered Confederacy. As a pro-Union Memphis newspaper put it:

> *Not content with the fact that the Secession fleet has been destroyed, the Secession army defeated and scattered, the control of the Mississippi obtained, and nearly all the important military posts occupied by the National troops, certain men still continue their active and secret efforts against the government.*

These "secret efforts" were often elaborately planned, as when Union forces found contraband medical supplies destined for the Confederate army hidden inside a coffin. Sherman tried to stem the tide by establishing a board of trade that prohibited the sale of weapons and ammunition, restricted the amount of medicines that could be purchased and required permits to import salt and salted meat into the city. Despite these efforts, smuggling continued at such a rate that, according to one contemporary observer, more than $20 million worth of supplies was funneled through Memphis to the Confederate military during the course of the war.

The widespread guerilla operations erupting in rural Shelby County, combined with the surreptitious trading with the Confederacy, convinced the commanding general that a firmer hand was needed. U.S. marines were sent on raiding parties to find smugglers, vacant property owned by Confederate sympathizers was seized and Sherman ordered the expulsion of family members of absent pro-secessionists. In his most decisive act as military commander of west Tennessee, Sherman burned to the ground

the nearby town of Randolph after guerillas repeatedly fired on trains and river transports. In attempting to further curb acts of violence, the Union commander declared that ten Confederate families would be expelled from Memphis each time a boat was fired on. Within a short time of issuing this order, forty families were removed from the city's limits.[13]

In November 1862, Sherman was relieved of his duties in Memphis, and Major General S.A. Hurlbut took command of the city. Like his predecessor, Hurlbut was determined to keep a tight rein on Memphis. In March 1863, Confederate guerillas attacked a passenger train at nearby Moscow, Tennessee, and robbed the passengers of their valuables. In response, Hurlbut ordered the provost marshal to exile the wealthiest "rebel sympathizers" from Memphis. Outraged at how brazen pro-Confederate Memphians were in their disdain for the United States, the new Union commander took a harsh stand with the local populace.

> *Giving aid and comfort to the public enemy is punishable with death and the leniency with which such persons have been treated must cease. Any person who shall hereafter offer insult by word or act to the United States or who shall express sympathy with the enemy or satisfaction at any imagined or real success of the Confederate arms will be arrested at once and severely punished.*

Despite the fact that Mayor Park was one of the worst offenders when it came to publicly expressing "sympathy with the enemy," Hurlbut allowed municipal government to operate much as Sherman had. In addition, the Union commander did not suspend the regularly scheduled city election in June 1863, and John Park was elected to his third mayoral term. Meanwhile, the contraband trade with the Confederacy continued to vex Hurlbut and his successor, Major General C.C. Washburne. "Memphis has been of more value to the Southern Confederacy since it fell into Federal hands," wrote Washburne in May 1864 when he closed the unrestricted trade policy that had been implemented by Sherman two years before. Like Hurlbut, Washburne granted permission for city officials to hold the yearly municipal election in June 1864. However, when he learned that John Park had been elected mayor for a fourth time, his patience came to an end. On July 2, Washburne suspended city government and appointed Lieutenant Colonel Thomas H. Harris acting mayor of Memphis. In his order, the Union general explained that

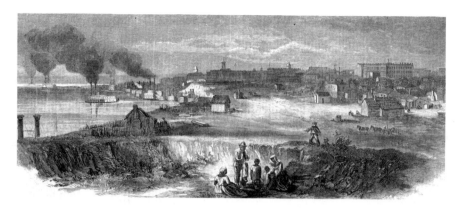

Sixteen thousand African Americans resided in Memphis when the Civil War ended in the spring of 1865.

> [t]*he utter failure of the Municipal Government of Memphis for the past two years to discharge its proper functions, the disloyal character of that Government, its want of sympathy for the government of the United States, and its indisposition to co-operate with the military authorities, have long been felt as evils which the public welfare require to be abated. They have grown from bad to worse, until a further toleration for them will not comport with the sense of duty of the commanding general.*

Harris remained acting mayor until after the war ended in April 1865. Despite the fact that Union troops remained garrisoned in the city, and that many whites could not vote owing to their civil and military service to the Confederate States of America, the regularly scheduled city election was allowed to take place on June 29, 1865. To no one's surprise, John Park received 1,356 votes and was again elected mayor during the first city election after the defeat of the Confederacy. To be sure, Memphis had escaped the destruction visited upon so many other Southern urban centers, and its economy was booming just as it was when Park was first elected mayor in 1861. But the Bluff City could not escape the consequences of the war.

On January 1, 1863, President Lincoln issued the Emancipation Proclamation, which freed all slaves within Confederate-held territory and allowed African Americans to serve in the Federal army. When the proclamation was issued, Memphis was no longer a Confederate city, and consequently, slavery continued unabated in the Bluff City, as well as in the rest of Tennessee. However, the proclamation was an important step in slavery's ultimate extinction. The United States Congress hastened that process when it supported the abolition of slavery by passing the Thirteenth

Amendment to the Constitution in January 1865. Tennessee adopted the measure in April, and on December 18, the Thirteenth Amendment was ratified; the scourge of slavery had finally been eradicated in Memphis and across the South.[14] As defeated Confederate soldiers began making their way back to Memphis, African Americans were experiencing their first tastes of liberty, including the right to vote. No one, white or black, knew how these changes would affect Memphis and its government as Mayor Park again resumed his duties.

"WITHOUT A DOLLAR OF CASH IN HER TREASURY"

W hen the war ended, there were sixteen thousand African Americans living in Memphis. The majority were refugees who had been steadily pouring into the city since its capture in June 1862. As a result of this migration into the Union lines, seven thousand black men joined the Federal army during the course of the war. The federal government designated Memphis as a collection depot for all black soldiers in the western theater, and the city was a subdistrict of the Freedmen's Bureau, which was created to prepare newly freed slaves for citizenship. The majority of African Americans settled in the neighborhood of South Memphis near Fort Pickering, which was home to the Third United States Colored Artillery Regiment. The existence of black troops was deeply resented by many white Memphians. Elizabeth Avery Meriweather, who had been exiled from the Bluff City during the war by Sherman, wrote of the journey back to her home in Memphis:

> *As we drew near Memphis the farm houses on the road side had been either deserted or burned to the ground. Some of the troops were black. They spoke no word to me, I spoke no word to them; their black faces and blue uniforms frightened me...During my walks from one shop to another I sometimes had to get off the sidewalk into the street in order to make way for these Negro soldiers—they walked four and five abreast and made not the slightest effort to let white women pass...Any stranger seeing those Negroes would have supposed the blacks not whites were masters in the South.*

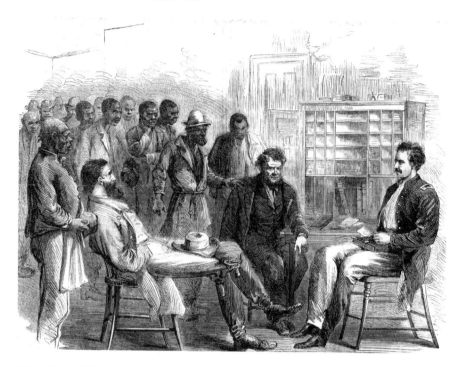

When the Civil War ended, Memphis was named a subdistrict of the Freedman's Bureau, which was created to prepare newly freed slaves for citizenship.

In the latter days of the war and into 1866, some black troops routinely abused their position, not only by pushing whites off sidewalks but also by firing their weapons into the air and pilfering items from local stores. When citizens attempted to stop them, violence often ensued. For example, when a grocer attempted to prevent the theft of his property, African American soldiers burned his shop to the ground. In a similar case, a black soldier shot and stabbed to death with his bayonet a white man whom he had accused of theft. Despite these wanton acts, the majority of African Americans, in and out of uniform, were primarily interested in securing equality and political rights for themselves and their families. Speaking in 1865, Sergeant Henry Maxwell of the Third Colored Artillery declared, "We want the rights guaranteed by the Infinite Architect. For these rights we labor. For them we will die. We have gained one; the uniform is its badge. We want two more boxes beside the cartridge box—the ballot and the jury box."

The majority of white Memphians, however, cared little for what African Americans wanted. As far as most whites were concerned, all blacks were savages who needed to be strictly controlled. This was particularly true of the city's Irish community. As we have seen, the "pinch-gut" Irish had

been treated as inferior by the so-called better element since the days of Catfish Bay. Routinely described in police records as "Irishman; no account" and "low Irishman," they were hounded by law enforcement officials, who despised them as much as African Americans.

John Park's election in 1861 changed all that. With one of their own as chief executive, the Irish soon dominated local government, and they were determined to stay in power no matter the cost. Many Irish Memphians felt deeply threatened by the large number of African Americans pouring into the city and feared that they might dislodge them as the city's most powerful ethnic group. Consequently, they used all means available to harass the local black population. The Irish-dominated police force constantly mistreated black Memphians, while Irish laborers attempted to prevent African Americans from working in skilled trades such as wagon driving. As 1865 ended, a deep-seated hatred emerged between black and Irish Memphians that needed little encouragement to turn violent.[15]

In January 1866, Major General George Stoneman arrived in Memphis to assume his duties as commander of the Department of Tennessee. Shortly after taking command, Mayor Park and Shelby County sheriff T.M. Winters approached the new commander with a request. Arguing that civil authority was "perfectly competent and capable of taking care of themselves," the mayor and sheriff asked that federal troops stop patrolling the city's streets. Stoneman reluctantly agreed, but he cautioned that he "held them responsible for the good order and quiet of the City of Memphis." Unbeknownst to everyone, the decision to rely solely on local police for law enforcement would soon have disastrous consequences for the people of Memphis.

In late April, the army discharged the last of its African American troops garrisoned at Fort Pickering. Having nowhere to go, the majority of former Union soldiers hung around South Memphis waiting for their final pay vouchers and celebrating their release. On May 1, a crowd of about one hundred drunken former soldiers congregated on South Street, where they began yelling very loudly and discharging their weapons into the air. As the crowd reached a fever pitch, a white wagon driver turned onto South Street and collided with a similar conveyance being driven by an African American. The two men began arguing, a punch was thrown and a brawl ensued. The soldiers rushed to defend their fellow African American, as did other black Memphians, who opened fire on police officers O'Neil and Stephens as they rushed to the scene.

Reinforcements led by Chief of Police Ben Garrett soon arrived and plucked two of the former soldiers from the crowd and carted them off to

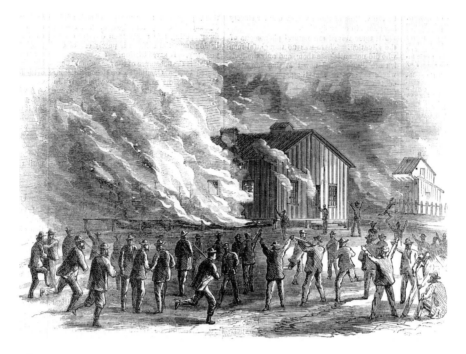

White Memphians destroyed twelve African American schools during the 1886 race riot.

jail. An angry crowd of blacks soon followed, and when the two groups met at a bridge over Main Street, the two sides opened fire on each other. Black forces seized the bridge and held it for a time until the police counterattacked and drove them from it. Black reinforcements poured fire from a small hill behind the bridge, which kept the police at bay and allowed the African Americans to retake the bridge. During the melee, armed whites reinforced the police, keeping up the firefight for several hours.

Meanwhile, City Recorder John C. Creighton was out for a buggy ride when he came upon the escalating violence. Frightened by what he saw, Creighton spurred his team into a gallop and headed for the sheriff. Sheriff T.M. Winters was in the midst of summoning a jury when the recorder arrived. Explaining the situation, the two hurriedly rode to General Stoneman's headquarters, where they reported the situation and requested troops to quell the disturbance. Not pleased to see them, the general asked if the sheriff had gathered a posse of armed citizens to address the violence. When Winters replied no, Stoneman refused to order troops into the city and then sternly lectured him on his responsibility to keep the peace. Glumly, the sheriff went out into the street to gather his posse.

As Sheriff Winters searched for volunteers, word was sent to Mayor Park, who was in the midst of a regularly scheduled meeting with the board of aldermen. A delegation of aldermen rushed to General Stoneman's headquarters, where he informed the aldermen that he would consider sending troops if the mayor would make his request in writing. A short time later, a communication was received from Park asking for troops, and Stoneman sent a detachment of regulars into South Memphis. Seeing the army marching into the area curbed the blood lust of the crowd, whose members slinked back to their homes. By late afternoon, peace was restored, and the troops returned to their garrison.

When night fell, many white Memphians, emboldened by false rumors of black depredation, swarmed into South Memphis and slaughtered every African American they saw. According to a reporter from the *New York Times*:

> *Large numbers of armed citizens repaired to the scene of the fight and commenced firing upon every negro who made himself visible. One negro upon South Street, a quiet, inoffensive laborer, was shot down almost in front of his own cabin, and after life was extinct, his body was fired into, cut and beat in a most horrible manner.*

The violence soon spread beyond the confines of South Memphis and engulfed other parts of the city. Instead of trying to stop it, police officers

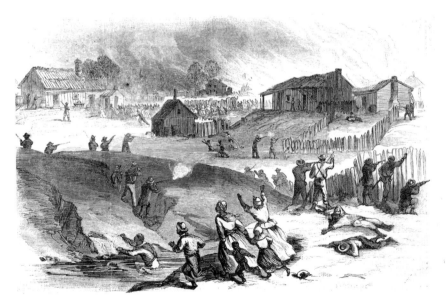

Forty-six African American Memphians were murdered during three days of rioting in May 1866.

41

joined in the indiscriminate killing of black Memphians. Surveying the scene the following morning, the *New York Times* correspondent wrote that the "bodies of most of those killed the evening before lay unburied where they fell, in some cases horribly mutilated and disfigured." In addition to murdering African Americans, the mob also burned down many of their homes, schools and churches.

The destruction continued until May 3, when General Stoneman declared martial law and placed guards at strategic points across the city with orders to disperse any gathering of citizens regardless of reason. This action finally brought the civil disturbance to an end. When order was finally restored, forty-six African Americans and two whites were left dead, and five black women had been raped. In addition, ninety-one African American homes, twelve schools and four churches had been destroyed. Unlike the federal troops, civil authorities did nothing to rein in the police or curb the wanton murder of African Americans during the riot. For example, Mayor Park took no responsibility after his initial request for troops, and sometime during the evening of the first, he began drinking and apparently did not stop until after the riot was over. According to one eyewitness, during the worst of the violence, the mayor made "an ass of himself" and was drunk. General Stoneman later testified that he attempted to contact Park but was told that "he was not in a condition to be communicated with."

Unsurprisingly, the government of Memphis was widely condemned for not containing the violence. The U.S. House of Representatives established the Select Committee on the Memphis Riots, which investigated the event and held hearings in the Bluff City. The select committee concluded that the mayor

> [s]eems to have been utterly unequal to the occasion, either from sympathy with the mob, or on account of drunkenness during the whole time…Park certainly did nothing to suppress the riot; and so far as his influence was concerned, it tended to incite it still further, disgracing himself, if he could be disgraced, and stamping with undying infamy the city of which he was the dishonored chief magistrate.

The actions of the police were equally condemned by committee members, who declared that "the persons composing the police force were of the most unworthy and disreputable character; monsters in crime, iniquity, and cruelty, and who during the riots committed acts that place vandalic barbarity far in the shade."[16]

Park's dismal performance severely damaged his political reputation and became a liability as he prepared for his reelection bid in the October 1866 municipal election. In order to improve his sagging fortunes, the mayor formed the conservative ticket, with two candidates for the state legislature. Opposing him was W.O. Lofland, who ran on a reform ticket and received the support of the Radical Republican–dominated Loyal League.

Park's allies in the press did not spare the invective when describing his opponents: "Let our Irish fellow-citizens remember that the Radicals... are the men who introduced negroes as witnesses before the Congressional Investigating Committee...to defame their reputation and stamp them as criminals of the darkest character." In a similar vein, Lofland was described as having "affixed a stain upon his character which fire cannot burn out, water wash out, nor time's all gnawing tooth eat out. He has proved himself a deceitful political trickster." These attacks had little effect on voters, who remembered Park's drunken bumbling during the civil disturbance. When Memphians went to the polls on October 14, they cast 544 ballots for the incumbent and 1,178 votes for Lofland. The defeat of Park not only ended one city executive's political career, but it also shattered the Irish coalition that had governed Memphis for more than five years.

The new mayor inherited a city government quickly sliding into financial ruin. Many property owners refused to pay their taxes as city leaders continued to make unwise investments, not to mention waste city funds. For example, the board of aldermen once paid a police officer a sizeable bounty after he accidently shot himself in the foot. Mayor Lofland further drained the city's treasury when he issued several thousand dollars worth of bonds to purchase stock in the Memphis and Little Rock Railroad. In addition, corruption was rife among some aldermen, who routinely demanded bribes before a contract was approved. Lofland and the aldermen were able to temporarily stem the tide of bankruptcy when the legislature allowed them to fund the city's debt.[17] While the financial crisis dominated the thoughts of white Memphians, their black neighbors were organizing to improve their social and political situation.

Since the end of the war, African Americans in Memphis and across the state of Tennessee had been pressuring the state legislature to expand black civil rights, particularly the right to vote. After several years of agitation, the Tennessee General Assembly guaranteed African Americans the right to vote in 1867, and the following year, they were given the opportunity to serve on juries and seek elective office. Black Memphians were naturally overjoyed with the passage of these measures and were determined to use their vote

to achieve equality under the law. In the 1867 gubernatorial election, for example, 3,600 African American Memphians cast ballots, the majority for incumbent Republican governor William G. Brownlow.

White Memphians viewed black involvement in the political process with a mixture of alarm and dread. The Conservative Party, made up of ex-Confederates and the Irish, raged against "the poor black men herded like cattle to the shambles, driven to the polls and forced to vote for the men of radical selection." On December 30, 1867, conservatives met at the Greenlaw Opera House to choose a candidate for mayor. When former congressman John W. Leftwich's name was put in nomination, loud cheers erupted, and he was quickly chosen by acclamation. In addition to declaring their "unqualified opposition to negro suffrage," Leftwich and the conservative ticket attacked the radicals for raising taxes and ignoring the rising crime rate.

Although the conservatives believed strongly in white supremacy and were opposed to black voting, they were also realistic. Knowing full well that African American votes had the power to crush their electoral hopes, conservative leaders met with members of the newly formed Black Voters Union Association and reached an understanding. As a result, on election day many blacks split their votes between the conservatives' two opponents, which allowed Leftwich to eke out a victory—2,406 ballots were cast for the conservative candidate, while his two opponents received a combined total of 2,054 votes, which suggests, given the number of registered voters, that some kind of alliance had indeed been reached between white conservatives and African Americans. As might be expected, the white mainstream press was ecstatic with the election results and paid homage to those who they believed were responsible:

> The result now is no half way triumph but a Waterloo defeat of all opposing hosts. And now we all rejoice, and every white man's heart is as big as a house…We wish to acknowledge our obligations and to return our thanks to the Irishmen of Memphis…With the great, patriotic Irish heart throbbing in their bosoms, they have stood forth…for white men's rights.[18]

With the city' financial crisis growing worse, the newly sworn mayor left for New York, where he negotiated a temporary loan that restored confidence in the city's credit and provided funds to pay expenses. However, while Leftwich was away, the fiscal situation grew worse. Alderman Edgar M. McDavitt was appointed mayor pro tem, and it fell to him to address

the bleak financial picture. All public improvements were halted, and the aldermen appropriated a $1 million bond issue to keep Memphis solvent. The bond measure was approved by voters in a special election, and it, along with Leftwich's temporary loan, improved the situation but did little to provide long-term financial stability. When the million-dollar appropriation was encumbered, for example, a mere $156,000 was left for future expenditures. For the rest of Leftwich's term, local government refused to appropriate large sums of money for city services. When, for example, Schools Superintendent James T. Leath asked for $10,000 to expand services to outlying areas, the mayor vetoed the request. The actions taken by Leftwich and McDavitt prevented a financial collapse, but long-term fiscal weakness continued to plague Memphis for well over a decade.

As might be expected, the budget crisis had an impact on local politics. There was a growing feeling as the 1860s came to an end that the city's current governmental structure was unsuited to the problems of the day. Consequently, a bill was passed by the legislature in December 1869 that dramatically altered the Bluff City's form of government. Under the charter amendment, the board of aldermen was reduced from twenty members to ten, and a second legislative body, the board of common council, was created with twenty seats. Collectively, this bicameral legislative body was called the General Council, and in order for ordinances and resolutions to become law, both houses had to agree to the proposal. Increasing the size of local government may have made sense as a plan to curb wasteful spending and corruption, but it came at a time when Memphis could ill afford the cost of an expanded bureaucracy.

The first election under the new charter was held on January 6, 1870. In addition to members of the boards of aldermen and common council, voters also chose John Johnson as mayor. A trained accountant, Johnson was appalled by what he found when he took office on January 10. According to the new mayor, the city was "without a dollar of cash in her treasury" and was on the verge of "financial ruin and actual bankruptcy." An able administrator, Johnson moved quickly to stem the financial crisis. He slashed expenses, set aside money in a sinking fund to pay part of the bonded indebtedness and collected back taxes. When property owners refused to pay, the mayor seized their properties and sold them for back taxes. As a result of Johnson's economy measures, the city's debt was reduced from $3,902,512 to $3,352,077. Johnson's able handling of the debt forestalled bankruptcy, but the city's financial state remained precarious throughout the 1870s.

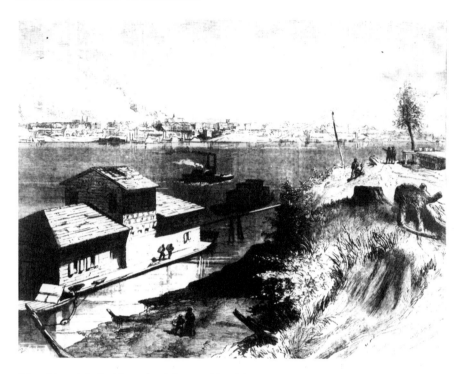

Memphis as it looked from the Arkansas side of the Mississippi River in 1871.

As we have seen, African Americans successfully pressured the Tennessee General Assembly to grant them the right to vote and hold elective office in 1867–68. Since that time, black Memphians had effectively used their votes to influence local elections but had yet to elect African Americans to political office. With its expanded legislative branch, the adoption of the new charter provided black leaders with the opportunity for which they had been hoping. Two African Americans, Alexander H. Dickerson and H.E. Pinn, ran for seats on the common council during the 1872 municipal election. Surprisingly, the white community took the news rather well considering that a mere seven years had passed since the 1866 massacre. On the eve of the election, Shelby County sheriff Marcus J. Wright reminded the citizenry that the "right to vote will be guaranteed to all without regard to color, race or previous condition, who possess the legal qualification."

Voting was light on election day and was so peaceful that the *Daily Avalanche* lamented that there was "not even…a fist fight to relieve the monotony." Mayor Johnson was reelected, and in the seventh ward contest, Dickerson and Pinn were both victorious, receiving 670 and 700 votes respectively. Owing perhaps to the continuing alliance between African Americans and

white conservatives, no one attempted to stop Dickerson and Pinn from running nor was violence or intimidation employed to suppress black voting. The editors of the *Daily Avalanche* merely remarked that the "election of colored councilmen in the Seventh Ward was, we presume, a necessity of the occasion for which both sides and all candidates were informed."

On January 8, the newly elected officials were sworn in, but when Dickerson and Pinn rose to take the oath, Mayor Johnson interrupted the proceedings to read a letter that claimed that Pinn was ineligible to serve. The message did not give a reason for this ineligibility, so Pinn was allowed to take the oath. However, the council did impanel a committee to investigate the matter, and on January 11, the members presented their report. Investigators found that Pinn had only resided in the seventh ward for three months rather than the six required by the city charter. Consequently, Pinn was removed from office and his seat declared vacant. When this action was taken, Pinn rose from his chair, bowed to his now former colleagues and left the council chamber. The council then chose the ironically named A.J. White to serve out Pinn's unexpired term. At the following year's municipal election, four African Americans—Joseph Clouston, Turner Hunt, Thomas Mason and Edward Shaw—were also elected to the board of common council.[19]

Eight months after Shaw and the other African Americans began their terms of office, a steamer from New Orleans landed at Memphis to pick up supplies. On board the ship were two very ill men who stayed behind when the ship steamed away. When the men died, it was realized that they had been suffering from yellow fever. Although not known at the time, this aggressive, highly communicable disease was spread by thousands of mosquitoes that bred every spring and summer in wells, cisterns and water casks throughout the Mississippi Valley. Within a few days, many Memphians residing nearest the river contracted yellow fever, and before long the disease had spread throughout the city. Even though mosquitoes actually caused the epidemic, the filthy streets of Memphis made matters worse. Dead animals, rotting food and other refuse were casually thrown into Memphis's alleys and gutters, while stagnant water collected in every crevice and pothole in the city. In addition, toilets drained into the uncovered Bayou Gayoso, which ran through the heart of the city and contributed to the awful stink that hung over the Bluff City.

As the stench of rotting garbage and excrement mingled with the smell of death, the board of health dithered over making an official diagnosis, but when its members finally did, thousands of Memphians fled the city to avoid contracting yellow fever. Meanwhile, the mayor and common council

continued to meet regularly, and on September 18, they appropriated $10,000 to pay for medical staff and supplies to treat the sick. But when a group of citizens complained that a yellow fever hospital had been placed in their neighborhood, the common council declared the facility "a detriment to the people" and passed a resolution making it unlawful to move patients outside of their neighborhood ward.

Like the legislators, the majority of city employees stayed at their posts and continued to conduct the people's business despite the threat to their lives. During the course of the epidemic, ten police officers, four firefighters and the city register succumbed to the disease. Not everyone remained faithful to his or her duty, however. The city's tax collector and his entire staff fled the city, while two police officers and one fireman also joined them. Despite others' devotion to duty, the bulk of relief efforts fell to the Catholic Church and an organization of physicians known as the Howard Association that built a hospital and spent $124,000 to treat the afflicted. Before a killing frost eradicated the mosquitoes and ended the epidemic in late October, five thousand Memphians had contracted the disease and two thousand had not survived.[20]

In addition to the horrible loss of life, the 1873 epidemic also devastated the city's economy. The Freedman's Bank collapsed, while the De Soto, First National, German National and Union and Planter's Banks suffered severe losses due to panicky depositors cleaning out their accounts. Owing to the number of residents who fled the city, $900,000 in property taxes was owed the city. As we have seen, the city's finances were already tottering before the epidemic, and they were hardly better off when the disease subsided. More importantly for the short term, these dire economic straits made it nearly impossible for Mayor Johnson and the common council to improve sanitary conditions in Memphis.

As the normal pace of life returned, Memphians turned their attention to the next municipal election, scheduled for January 1, 1874. Mayor Johnson declined to run for another term, and both conservative Democrats and Republicans fielded a full slate of candidates. Former Confederate officer J.J. Busby was nominated by the Democrats, and John Logue was the chosen candidate for the GOP. The Republican ticket also included African American council member Edward Shaw, who ran for the at-large city wharf master position. By December 1873, black participation in the political process had been grudgingly accepted by the majority of white Memphians. As the archly conservative *Daily Appeal* declared to its readers:

Memphis cannot prosper until her citizens become a homogeneous people. Every good man sees the dangerous tendency of race lines and color prejudices and should seek by all means to prevent such unworthy issues. In elections, neither the whites nor the blacks should band together as if their destiny and interest were distinct; and at such a time race organizations should be dissolved and all should march to the polls as American citizens anxious to promote the prosperity of the community.

On December 29, the Republicans held a mass meeting at Cochran Hall to introduce the candidates and outline the party's platform. Included among the speakers was Ed Shaw, who explained to the assembled throng that he "did not come before them as a colored man claiming their votes and neither did Mr. Loague come as an Irishman." Despite his declaration that his candidacy was not about race, Shaw apparently could not let the moment pass without expressing the bitterness that many African Americans felt over the 1866 disturbance. He bemoaned the fact that "not a cent had been paid for the damage done to the colored churches and schoolhouses" and "not a tear had been shed for those who had been brutally shot down and killed." At the close of his speech, Shaw implored black voters to make common cause with the Irish and "vote together side by side."

Two days later, the Democrats, styling themselves the People's Ticket, followed the Republican example and gathered at the Grand Opera House. During the course of the evening, Busby promised that he would govern "with a due regard to economy" and criticized Logue for employing "several foul-mouthed parties to abuse him and tell falsehoods about him." Two African Americans also spoke to the large crowd. H. Trowbridge urged fellow Democrats to vote against Shaw, and Albert Thomas, whose nickname was "Uncle Tom," explained that African Americans would "get a share of the work of the city" if Busby was elected mayor.

Early in the campaign, Busby proposed the construction of a modern sewer system to improve the city's appalling lack of sanitation, but Republicans attacked the measure as wasteful spending, and the proposal was quietly dropped. In the end, however, it was not the sewerage issue or even the economy that influenced the outcome of the race. Ultimately, it was a coalition of Irish, German and African American voters that swept the Republicans into office. John Logue was elected mayor by eight hundred votes, and roughly the same number of ballots was cast for Ed Shaw, who became the city's wharf master and the first African American to win a citywide election.

There was little time for the new mayor to celebrate his victory, however. The financial situation remained grave as the bonded indebtedness continued to rise, and tax collections continued to fall. Things became so desperate that the council mortgaged some city property and sold other parcels in order to maintain solvency, but these were merely stopgap measures. As Mayor Loague and the council tried to deal with the ongoing financial crisis, matters were made worse when wealthy Memphians formed the People's Protective Union to agitate against the waste and inefficiency that had often dominated the efforts of local government. The organization's solution was to eliminate the city's democratically elected local government and replace it with a state-appointed three-man commission: "Our purpose is to remove our city government, and the business interest of the city, away from popular elections of the times and from all partisan influences."[21]

Owing to widespread opposition, the members of the People's Protective Union were unsuccessful in their attempt to chloroform city government, but their efforts did influence a major charter change that was adopted in 1875. The state legislature, recognizing Memphis's budget crisis, severely limited the city's fiscal authority by reducing the maximum property tax rate to $1.60 and requiring that "the General Council shall not engage or contract for any item of expense, without first apportioning a sufficient amount…to pay such engagements or contracts…otherwise the individual members of the General Council…shall be held individually liable." Although these reforms were necessary and could have righted the tottering city treasury if adopted earlier, they came too late to prevent municipal bankruptcy.

In late 1875, Mayor Loague decided not to seek reelection, which forced local Republican leaders to scramble for an alternative candidate. Failing to find a suitable choice, the GOP asked Loague to run again, and he reluctantly agreed. As Republicans were finalizing their ticket, the Democrats nominated retired criminal court judge John R. Flippin as their standard-bearer in the municipal election. The GOP tried to hold on to its African American/German/Irish coalition, but hundreds of black voters deserted them for Flippin and the Democrats. For example, on election day, a newspaper reporter happened upon an older African American who was conducting a mock funeral for Ed Shaw and the GOP. At the conclusion of his oration, he declared that Republican leaders had "done popped the last whip over this child; I done cut loose now and voted for Mr. Flippin." Later that day, the same journalist witnessed a group of African Americans jeer Shaw as he drove up in his buggy. As these demonstrations suggest, the Democrats defeated the GOP in the mayor's race, with Flippin receiving 4,345 votes out of 7,509 ballots cast.

With the election over, the People's Protective Union continued to agitate for drastic governmental reform. Aided by city attorney Sam Walker, the association lobbied to dissolve the city's charter and place municipal affairs under the control of the Shelby County Quarterly Court. The proposal was soundly rejected by citizens and political leaders alike, but the fact remained

In 1878, Howard Association physicians and nurses established camps in Memphis to treat the sick and dying.

that the city's finances were in an appalling shape. By the end of 1876, the city was more than $1 million in debt, despite the fact that Mayor Flippin had spent far less than the appropriated budget of $389,000. As creditors began suing the city, Flippin and the council were forced to cut the salaries of city employees by 20 percent and reduce the pay of public school teachers. These measures may have helped Flippin win reelection against former mayor John Johnson in the 1878 city election, but they did little to stave off financial ruin. By the middle of that year, Memphis was, in effect, bankrupt as local government was unable to pay its expenses and was forced to pay employees with scrip instead of money. Basic municipal services were simply left undone, including, much to the dismay of the city board of health, basic street cleaning.[22] As Mayor Flippin tried to find a way out of bankruptcy and filth piled high in the streets, word reached the city that yellow fever was spreading through the Lower Mississippi Valley.

Remembering what had happened in 1873, Mayor Flippin ordered all river vessels to dock at President's Island south of Memphis and submit to inspection and disinfection. The quarantine was spread to include rail traffic, but despite their best efforts, the disease began to appear in early August. The first yellow fever deaths occurred in Memphis on August 13, 1878. Alarm quickly spread; passenger trains jammed with people and roads clogged with wagons became a common sight as twenty-five thousand people fled Memphis. Included in that number were a majority of the city council and a good many governmental employees, who hastily left behind the people they swore to serve. Mayor Flippin remained at his post, but without a functioning bureaucracy there was little he could do.

On August 16, a mass meeting was held at the Grand Opera House, where, in conjunction with Mayor Flippin and the board of health, the Citizens' Relief Committee was established to provide basic municipal services, distribute food rations and coordinate efforts to treat the sick and bury the dead. During the meeting, Flippin agreed to borrow against future tax revenue in order to provide the committee with $30,000 for its immediate relief efforts. The city was quarantined by armed guards empowered to forcibly block anyone from entering or leaving Memphis, and the committee hastily constructed several refugee camps in and around the city. Surplus army tents were secured from the War Department to house the sick and dying, and the forty doctors and seven hundred nurses organized by the Howard Association were assigned to each ward to provide healthcare for the afflicted. In addition to caring for the sick, the committee also distributed blankets, medical supplies and eighteen thousand kits of food rations each day.

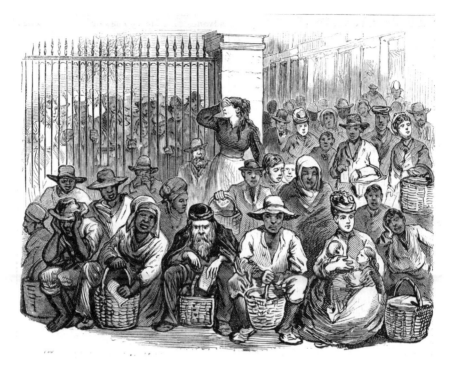

Food and other necessities were scarce in Memphis during the 1878 yellow fever epidemic.

By mid-September, two hundred people per day were dying, and about ten thousand Memphians were suffering from yellow fever, including Mayor Flippin and several members of the citizens' committee. The depths of the tragedy soon overwhelmed the relief efforts; food distribution was disrupted, and the neighborhood clinics had to close due to a lack of medical personnel. As corpses piled up in the streets like garbage, the remaining members of the citizens' committee ordered all Memphians to "leave the city as the only hope for saving them from entire destruction." As September ground down, the number of deaths subsided, and a killing frost arrived on October 19, bringing with it an end to the epidemic.

When Mayor Flippin rose from his sickbed, he found a Memphis transformed by the yellow fever epidemic. Five thousand of its citizens were dead, thousands of its residents had left—never to return—and its economy was in tatters. But the crushing municipal debt remained, and now the city had few ways to pay it. An editor for the *Daily Appeal* put it well when he wrote, "We must have relief from ignorance and incompetence in government, the cormorant greed of city and foreign creditors, and the

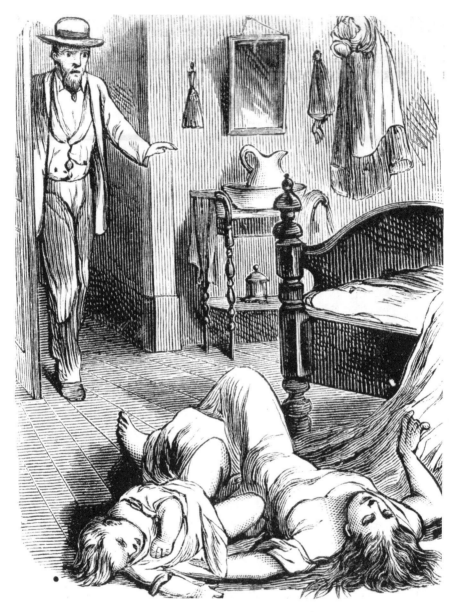

Yellow fever killed five thousand Memphians in the summer of 1878.

visitations of a disease from which we ought to be, and would with proper sanitary regulations be, exempt. We must make a change."[23]

Could Memphis find the will to make those changes? No doubt this was a question on the minds of many, including Mayor Flippin, as 1878 came to a close.

54

"A Beautiful City, Nobly Situated on a Commanding Bluff"

O n New Year's Eve 1878, a citizens meeting was held at the Greenlaw Opera House. During the course of the proceedings, a resolution was adopted calling for the kind of radical change first suggested by the People's Protective Union in 1874. The proposal declared that "the city government ought to be abolished" and that "a Taxing District should be established in its place." A committee was then formed made up of Dr. D.T. Porter, J.R. Godwin, W.S. Bruce, Jerome Hill, I.N. Snowden, J.M. Goodbar and J.T. Pettit to craft a bill for the Tennessee General Assembly. As the committee began its work, Mayor Flippin continued to search for an alternative to municipal suicide. On January 10, he addressed a joint session of the boards of aldermen and common council, urging them to hire an agent to confer with creditors in hopes that they would finally agree to accept his long-standing proposal of fifty cents on the dollar for each debt owed. Rebuffing the mayor, the joint council voted to table the measure.

In reality, it didn't matter, as creditors refused to accept the Flippin plan while continuing to sue the city for moneys owed them. In response to these suits, the courts issued writs of Mandamus, which required city government to impose new taxes to pay debt owed bondholders. By mid-January, the city had been ordered to pay nearly $80,000, and more writs were expected. This was too much for the board of aldermen, who passed a resolution on January 13 calling on the state legislature to abolish the city charter. The following day, the committee finished work on its charter repeal bill, and it was forwarded to the General Assembly for action. Realizing that this

negated any possibility of his plan being accepted by either creditors or local government, Mayor Flippin announced that he would rather see the charter repealed than have Memphis under the thumb of rapacious bondholders.[24]

On January 26, the bill passed the Senate, and it sailed through the House, becoming law on the last day of the month. In its final form, the original proposal was divided into two bills. The first act completely dismantled city government by repealing its charter, dismissing all elective offices and eliminating the power to levy taxes. The second measure established a mechanism for overseeing a city that had lost its charter. A bicameral legislative council, made up of three fire and police commissioners and five public works supervisors, was established to govern any city in Tennessee that had lost its charter. Just as the People's Protective Union had recommended in 1874, voters had little say in who was chosen to serve on the legislative council. Of the three police commissioners, only one was popularly elected, while the other two were appointed by the governor with the consent of the state Senate. The membership of the board of public works was selected in a similar fashion, with three elected and one each appointed by the governor and Shelby County Quarterly Court.

The powers of the legislative council were limited to passing local ordinances and overseeing day-to-day law enforcement and public sanitation. More importantly, the power to levy taxes was taken from local government and given to the state, and the Shelby County Taxing District was legally prevented from going into debt. On January 31, 1879, Tennessee governor Albert Marks appointed members to the legislative council and selected Dr. David T. Porter as president of the taxing district. Six days later, the first election was held under the new form of government. Voting was light, with only 4,418 ballots cast, and there was little enthusiasm for the partisan campaigning exhibited by the "old ward municipal rings." Of those who were chosen for the legislative council, the most notable was real estate investor John Overton Jr., the grandson of proprietor John Overton. However, not a single African American was selected for a government post. In addition to wiping away Memphis's municipal debt, the creation of the taxing district also swept black political leaders out of office.

For the first few months, President Porter and the legislative council groped to define their authority and implement reforms that fit within the confines of the taxing district statute. Working with the state legislature, they were able to increase the local tax rate to $1.15 per $100.00 assessed, which provided needed revenue for public safety. Along with increasing the police department's budget, the council attempted to weaken criminality by passing

an ordinance closing saloons and other places of business on Sundays. In addition, all forms of gambling were made illegal.

Crime was certainly a major problem, but the most important issue facing the city was that of sanitation. Concerned citizens established the Auxiliary Sanitary Association to assist local government in cleaning up Memphis, purchasing garbage collection equipment for city use and convincing the council to empower sanitary inspectors paid for by the association. The ASA also worked assiduously to improve the disposal of human waste. Within a decade, six thousand filthy privies had been replaced by more than seven thousand modern water closets. Also, streets were improved when the district's engineering department removed rotten wooden paving and replaced it with gravel. The combination of latrine and street improvements, along with increased garbage collections, meant that Memphis was cleaner than it had been in years. But more effort was needed to reform Memphis's overall public health.

Mark Twain described Memphis as "a beautiful city" whose "streets are straight and spacious" when he visited in 1882.

In November 1879, a group of Memphians attended a meeting of the American Public Health Association in Nashville, where they listened intently to sanitary engineer George E. Waring Jr. describe the benefits of his small-pipe sewer system. Impressed with Waring's system, the Memphians asked him to develop a sewer plan for the city, which he promptly did. President Porter, the legislative council and the Shelby delegation to the General Assembly convinced Governor Marks to call a special session to consider granting the taxing district permission to levy a 2 percent tax to pay for Waring's sewer. After lengthy debate, the legislature authorized the tax,

and Waring began construction in late January 1880—24.2 miles of sewers were laid the first year, and by 1886 there were more than 43.0 miles of pipes laid and 35.0 miles of subsoil drains. The system cost a mere $291,600 and, when finished, was completely paid for. The combination of street cleaning, water closet construction and the Waring sewer system transformed the physical landscape of Memphis, and they were the most important governmental accomplishments of the nineteenth century. In his *Life on the Mississippi*, the celebrated American writer Mark Twain described a visit to Memphis in 1882: "It is a beautiful city, nobly situated on a commanding bluff overlooking the river. The streets are straight and spacious, though not paved in a way to incite distempered admiration. No, the admiration must be reserved for the town's sewerage system, which is called perfect."[25]

President Porter, despite his many successes, apparently grew weary of his duties and abruptly resigned in early June 1881. Two men, Police Commissioners Michael Burke and John Overton Jr., served jointly as president until the January 1882 municipal election. Despite his withdrawal, Porter remained involved in local politics, endorsing the People's Ticket headed by merchant David Park Hadden and including African American

Lymus Wallace was elected to the legislative council in 1882 and was the last African American to hold public office in Memphis during the nineteenth century.

Charles W. West. Not long after the formation of the Hadden slate, Edward Shaw joined forces with wealthy African American landowner Robert Church Sr. to form a rival ticket for the legislative council. Lampooned by the *Daily Appeal* as the "Pshaw" ticket, Church and Shaw were successful in wooing Charles West away from the Hadden camp to form a more racially balanced slate. The People's Ticket countered by replacing West with Lymus Wallace, which gave it one black candidate to Shaw's two. President Porter's endorsement, combined with a token African American

candidate, gave the People's Ticket an advantage, which was borne out on election day. Hadden was easily elected to the Fire and Police Commission, while 2,339 ballots were cast for Wallace to Church's 1,643. Not long after the election, Hadden was appointed president and, soon after taking office, was forced to confront the unresolved issue of municipal debt.

When the taxing district was established in 1879, a majority of creditors assumed that the money owed them by the City of Memphis had been wiped away or repudiated. However, President Hadden and other city leaders realized that debt repudiation would not be in the best interest of the city's future. Hadden also believed that the courts required the taxing district to assume the debt. Consequently, a committee of sixteen prominent citizens was formed to negotiate with the bondholders on the basis of the Flippin plan of fifty cents on the dollar. A majority of creditors agreed to these terms, but a major holdout was dry goods magnate Frederick Cossitt. When Cossitt refused to budge, Hadden offered him a $4,000 payment from a public school fund created by the legislature. Cossitt accepted the payment, as did other recalcitrant bondholders. With the old debt behind them, the legislative council began selling taxing district bonds, and by the summer of 1885, more than $200,000 worth of bonds had been purchased, not only by local banks but also by individuals, such as African American millionaire Robert Church Sr.

In the interest of economy, the president had scaled back the number of accountants and clerks to such a degree that there were few inspections of city financial records. Without proper oversight, dishonest city employees felt free to steal $40,000 from the city's coffers during Hadden's administration. The losses were hardly noticed because tax revenue was augmented by thousands of dollars in fines collected from illegal gambling establishments. When the State of Tennessee outlawed gambling in 1883, taxing district officials simply collected thousands of dollars in fines while doing nothing to curb the practice. Hadden justified this arrangement because it kept gambling in restricted areas and improved the city's finances.

These kinds of questionable accounting practices, along with his lax enforcement of the anti-gambling statute and his reliance on the political strength of African American voters, led many white Memphians to abandon Hadden as the 1880s came to a close. Anti-black sentiment was on the rise throughout Tennessee, and Memphis was no exception. For example, the legislature passed the Dortch Law in 1889, which required that all ballots be cast in secret. On the face of it, the law would seem to be a reasonable attempt to curb election fraud, but given the fact that a majority of black Tennesseans lacked the ability to read a complicated ballot without

assistance, the measure was clearly designed to restrict African American voting. In a further attempt to disenfranchise black citizens, the General Assembly established a poll tax in 1890 that required eligible voters to pay a fee each time they cast a ballot.

As a result of the taxing district president's long-standing support of gambling and black voting, anti-Hadden forces within the Shelby County Democratic Party held a nominating convention in November 1889 to choose candidates for the upcoming municipal election. The committee, determined to keep the incumbent president off the ticket, outmaneuvered the pro-Hadden forces and selected wealthy businessman W.D. Bethell as the Democratic nominee for city executive. Although gambling was a factor in Hadden's defeat, the real reason was his alliance with African American voters. As one newspaper editor put it, "In the South the Democratic Party stands for pure government and for white government; the Republican Party represents corruption and ignorance. Those who touch it are defiled."

Not all Democrats were opposed to black political involvement, however. Calling on "all, regardless of race, to be with them in their movement," the Citizens Independent Ticket was formed to oppose the regular Democratic slate. Although it tried to re-create the old black-white, Democratic-Republican coalition, the Citizens Independent Ticket did not include an African American candidate, just like the Democratic slate. The election was a close one, but the Democrats defeated the Independents and W.D. Bethell was named taxing district president. The outcome of the 1890 municipal election was significant because it ushered in the total domination of Memphis politics by the white-controlled Democratic Party. Neither African Americans nor white Republicans would play significant roles in public affairs despite the fact that both remained important voting blocs in Memphis and Shelby County. In fact, it would not be until the 1960s that Memphians would again elect blacks and Republicans to public office.

The extent of Hadden's sloppy accounting practices and the resulting theft of city funds was not fully revealed until two days after the election. Shortly after Bethell was selected president by the legislative council, Hadden was indicted for fraudulent breach of trust but never convicted. The former president's indictment apparently had an effect on his successor, for Bethell moved quickly to prevent any further financial mismanagement. The new president kept a tight rein over governmental expenditures by personally approving all budgetary requests made by municipal departments and signing every check cut to cover the cost. Fortunately for the long-term solvency of the city, Bethell chose a trained accountant, Henry J. Lynn, to

serve as taxing district secretary. In addition to making daily deposits of collected funds in the county trustee's office, Lynn also routinely examined the district's books and adopted standardized bookkeeping practices.

As a result of these reforms, city finances improved dramatically, so much so that the tax rate was reduced from $2.35 to $1.75. However, the strain of implementing these reforms, not to mention minutely overseeing the city's finances, took its toll on Bethell's health, forcing him to resign on March 16, 1891. W. Lucas Clapp was then appointed by the governor to fill Bethell's council seat, and he was elected president by the voters of Memphis in the January 1892 municipal election.[26]

As Clapp settled into the president's office, the relationship between white and black citizens again turned ugly in the neighborhood of South Memphis. In January 1889, several African American businessmen established a cooperative grocery store near the curved intersection of Hernando (now Mississippi Boulevard) and Walker. Called the People's Grocery, it catered to black customers in the area, taking customers from a white-owned store across the street. Over time, the owner of the white store, W.H. Barrett, watched his customer base dwindle, and he vowed to destroy his competition by any means available. In 1892, Barrett complained to local officials that large crowds were congregating at the People's Grocery and causing raucous disturbances. As a result of Barrett's complaint, the Shelby County Grand Jury indicted the principal owners of the store, Calvin R. McDowell, Thomas H. Moss and William D. Steward, in March 1892.

When sheriff's deputies attempted to arrest the owners, they were met by armed black men who had gathered to defend the store against a rumored attack. The armed men assumed that the deputies were a lawless mob and opened fire on them, wounding several officers. Overcoming the resistance, deputies arrested McDowell and Steward, while Moss and twenty-nine other African Americans were rounded up after the firefight. Four days later, on March 8, 1892, nine armed white men entered the jail and demanded the release of McDowell, Moss and Steward. Let go by the jailer on duty, the three grocery store owners were marched to an open field and coldly executed. The Sheriff's Department did not investigate the killing, and the murderers were never brought to justice. In response to this flagrant miscarriage of justice, thousands of African Americans fled Memphis for the Indian Territory of Oklahoma.

Meanwhile, sentiment was growing throughout the city that it was time to bring the taxing district to an end and return Memphis's governmental charter. In late 1892, a committee was formed by Democratic Party leaders,

along with representatives of the legislative council, the Cotton Exchanges and several other business associations, to work with the legislature to restore the city's charter. The following year, in 1893, the Tennessee General Assembly passed three bills that reintroduced self-government to Memphis. Instead of simply restoring the political structure that had existed before 1879, the legislature established the mayor and bicameral legislative council as the official form of government to be elected by the people in at-large elections. The new government was granted the authority to levy taxes and allocate its spending, but the General Assembly retained the power to set the tax rate and place restrictions on total collections.

The fourteen years that the taxing district had governed Memphis was one of the most significant in the city's history. A modern sewer system was constructed, and sanitation measures were adopted that transformed the streets of Memphis. In addition, the long-standing debt crisis was finally solved, and the city's finances were stabilized. But there was a more sinister aspect to the period in that the city's two most powerful voting blocs, African Americans and the Irish, were banished from the halls of government. In their place stood wealthy white elites who paid little attention to the needs of African Americans and poor whites.

The first election in the post–taxing district era was held in January 1894. Three candidates, all Democrats, ran for mayor, including incumbent W. Lucas Clapp. Challenging him were former taxing district president David Park Hadden and John Joseph Williams. Clapp and Hadden represented the white elite that had ruled the city since 1879, while Williams and his supporters tried to reconstitute the old Irish/African American coalition that had so recently been swept from power. Relying mostly on the support of such underworld figures as George Honan, Jim Kinnane and Big John Brennan, Williams made little headway beyond the dwindling Irish population and segments of the black criminal class. Of course, Hadden was also burdened by his prior association with the gambling interests, and he worked hard to overcome this sordid image. Hadden campaigned furiously throughout the city, holding mass meetings and organizing a parade with the former president in a mule-drawn wagon trailing behind an "electric car gaily decorated and loaded with a band of music."

While Hadden employed garish tactics to get his message across, Clapp pointed to his record of efficient government, and Williams reminded voters that he had been endorsed by the Trades Council, which governed several local labor unions. The Clapp Ticket, which described itself as filled with "tax-paying Democrats," avoided criticizing Hadden, apparently feeling

that he had no chance of victory, instead saving most of its vitriol for Williams's supporters, whom their surrogates in the press called "hoodlums and ward heelers of the lowest and toughest type." In the end, Williams was unable to overcome Clapp's middle-class support, nor was Hadden ever able to articulate a coherent reason for wanting to be mayor beyond that of redemption for his 1890 political defeat and legal indictment. Clapp easily won reelection, which meant that the white elite coalition remained in power.

During Clapp's administration, the sanitary and financial policies that were put in place in the 1880s were continued, and the mayor also lent his support to the creation of the first public library in Memphis. Financed by a $75,000 gift from the estate of Frederick Cossitt, construction was secured when Clapp and the legislative council agreed to provide public land and pay the operating expenses of the new library. Meanwhile, many in Memphis, including the mayor, grew concerned by the growing number of suburbs that were being built on the eastern fringes of the city limits. In 1890, the suburb of Madison Heights, located on a swath of land between Poplar and Union Avenues, was incorporated, which spurred other outlying neighborhoods to establish their own suburban governments. The communities of Binghampton and Idlewild were incorporated in 1895, Lenox in 1896 and, finally, the town of Manila in 1898. Memphis officials viewed this spate of incorporations not only as an obstacle to the city's future growth but also as a breeding ground for future epidemics. Mayor Clapp, in particular, believed that the solution to the suburban problem was to expand the city limits beyond the incorporated towns and annex them into Memphis.[27]

As the mayor began his annexation drive, his former opponent, County Trustee J.J. Williams, continued to build his Irish/African American coalition in the hopes of unseating Clapp in the next municipal election. As the political season got underway, few voters were surprised when Clapp made annexation the centerpiece of his reelection bid. Williams, however, straddled the issue, never coming out against but also carefully avoiding any endorsement of the proposal. Many Memphians were deeply concerned that annexation would lead the city back on the road of financial instability, and they turned to Williams as the perceived anti-annexation candidate. The combination of Williams's superb political organization and the anti-annexation sentiment of many voters led to his victory in the January 1898 mayoral election.

Shortly after the inauguration, however, Memphians were stunned to hear Mayor Williams come out in favor of annexation. Under the mayor's direction, an ordinance was quickly passed by the legislative council annexing

Idlewild and Madison Heights. The approval of the General Assembly was also required, so the Shelby County delegation persuaded Tennessee governor Bob Taylor to call a special session to hear the measure. In record time, a bill was passed, and Governor Taylor signed it on February 1, 1898, a mere twenty-six days after Williams's election. Trying to hold down costs, the new law exempted the annexed territory from paying taxes for fire, police and streetlight services for ten years, which meant that it would go without these services until 1908. Anti-annexation forces sued the city, and the Tennessee Supreme Court declared the annexation unconstitutional because the new residents were denied equal access to all city services.

In the fall of 1898, a group of citizens, undaunted by the Supreme Court's ruling, formed the Committee of Fifty to organize a Greater Memphis campaign throughout the city. A petition was circulated calling for the annexation of several surrounding communities; however, bowing to anti-annexation sentiment, it was not as comprehensive as the original boundary proposal. Signed by 3,100 Memphians, the leaders of the new organization were so overwhelmed by this support that they renamed themselves the Committee of the People. During a well-attended meeting at

By the end of the nineteenth century, Memphis had become a major southern transportation hub, as can be seen in this 1895 photograph of Front Street.

the Merchant's Exchange building, the committee drew up an annexation line that stretched the city's boundary to Cooper Avenue on the east, Trigg Avenue to the south and Vollentine Avenue to the north. Once the line was agreed upon, a resolution was adopted calling on the legislative council to endorse its annexation plan and hold a referendum so that citizens in the affected areas could vote on the issue.

On the day the resolution was brought before the council, so many citizens flooded into city hall that Mayor Williams became concerned for their safety. It was decided to move the proceedings to the nearby criminal court to allow more people to securely attend the gathering. The council, faced with a raucous crowd demanding action, endorsed the committee's resolution and scheduled a referendum for early November. The hard work of the People's Committee paid off when, on election day, voters in and out of the city cast 3,500 ballots for annexation, while only 50 disapproved of the measure. Flush with victory, Mayor Williams rushed to Nashville, where he worked with the Shelby delegation to craft an annexation bill for Memphis. The final product followed the lines recommended by the People's Committee and the legislative council while avoiding the unconstitutional aspects of the first annexation law. The measure was passed by the General Assembly at the beginning of the new year and signed by Governor Benton McMillen on January 27, 1899.

With the governor's action, the corporate limits of Memphis were doubled, and the shape of the city was made a nearly perfect square. The 1899 annexation deeply affected the future development of the Bluff City. In addition to expanding the physical size of Memphis, it also increased its population, improved the city's position as a major transportation hub and enhanced public health. However, it did have one flaw. Acting on the belief that the newly annexed territories should not be held responsible for the Bluff City's past debts, the law set the suburbs tax rate lower than the rest of the city.

Mayor Williams and the legislative council successfully extended sewers and water mains into the annexed territory, but they were far less successful in implementing another civic improvement. In 1900, the city only had 175 miles of streets, but only 12 were paved; a fact that was bemoaned by business leaders as well as the *Commercial Appeal*, which declared that "the crying need of Memphis today is improved streets." Owing to sewer expenditures, there was little money for street paving, and property owners were opposed to a tax increase to pay for street improvement. Despite this, the legislative council was able to pave an additional 10 miles of streets by 1905. Although the actual paving was woefully inadequate, the

Front Street, circa 1898. Despite its phenomenal growth during the nineteenth century, Memphis had only twelve miles of paved streets in 1900.

Williams administration was successful in making the streets more uniform by renumbering all city buildings and residences. When many residents refused to accept the plan, the legislative council levied steep fines against them, which, combined with the post office's refusal to deliver mail to the old addresses, overcame their resistance.[28]

Like other urban residents across the United States at the beginning of the twentieth century, Memphians were beginning to expect more from their municipal government than traditional services such as law enforcement and sanitation. In particular, there was a growing desire for improved recreational opportunities through the creation of a modern parks system. There were a few small parks in the city, such as Court Square, but none was adequate for those seeking the pleasures of a natural landscape. Mayor Williams drafted a bill in the fall of 1898 granting the legislative council authority to "issue bonds for the purchase and condemnation of lands for parks and parkways and the election of a board of park commissioners."

The General Assembly passed Williams's bill on March 27, 1899, and the council established a park commission the following year. While the newly formed commission was making preliminary plans, one of the

famed designers of New York's Central Park, William Olmsted, arrived in the Bluff City to survey the city and make recommendations for an up-to-date park system. Olmsted reported to the park commission that Memphis had outgrown the ability to sustain a system of small neighborhood parks. Instead, he proposed the construction of two large parks with a series of tree-lined parkways to connect the two. Impressed with Olmsted's report, the park commission moved quickly to implement his recommendations.

Funds were secured to purchase land for two parks, one near the Mississippi River and a second on the eastern edge of the city. Named Riverside and Overton respectively, the two parks were eventually connected by a series of boulevards lined with lush plants and trees. Overton Park, in particular, was embraced by the citizens of Memphis as a municipal treasure that should be constantly nurtured and protected. As Memphis historian John Preston Young put it, Overton Park was filled with "trees that were here when De Soto came [that] rear their mighty heads at intervals, and one buried in the great wilderness can discern no evidence that despoiling civilization exists anywhere near." The park system, combined with Williams's other accomplishments—annexation, an expanded sewer system and improved streets—made him a very popular city executive, so much so that he was reelected mayor in 1902 without opposition, the second time that had happened in Memphis history. However, a chink in his political armor existed that threatened to tear his second administration apart.

An important element of Williams's coalition was the criminal classes, led by such well-heeled procurers of vice as George Honan and Mike Shanley. Honan, for example, controlled all gambling interests north of Madison Street, and Shanley had murdered gangland boss Ed Ryan during a fierce gun battle at Montgomery Park. These men, and others like them, oversaw several competing underworld empires that struggled for supremacy, leading, as Ryan's death suggested, to a high murder rate. Prostitution and gambling were easily accessible to residents and visitors alike, as were narcotics. According to a 1900 police report forwarded to Mayor Williams, "the sale of cocaine has reached such an alarming extent that the department is unable to cope with its ravages."

The mayor's cozy political relationship with the underworld left some Memphians uneasy about who was actually pulling the strings in city hall. It did not help Williams's image when he declared that the city charter only required him to regulate and control vice, not eliminate it. In the spring of 1902, several local pastors preached against vice in an attempt to pressure the mayor into enforcing anti-gambling and prostitution statutes, especially on the Sabbath.

The following year, cooperage manufacturer Walker Wellford, angry at local government for canceling a lease held by his company and allegedly concerned about the slow pace of street improvement, demanded to examine the city's books because he "could not understand with the high rate of taxation why the city was in its deplorable condition." Williams refused his request, but after a lengthy court battle, the Tennessee Supreme Court ordered the mayor to open the books for Wellford's inspection. The National Audit Company was hired by Wellford to examine the city's accounts, but all they could find was that there was a "general lack of system in the accounting methods of the city."

Despite its inability to ferret out corruption, the Wellford affair gave strength to those opposed to the mayor and, correspondingly, struck fear in the heart of the Williams coalition. Consequently, at the next scheduled election, Williams and his supporters were determined to employ whatever means were needed to retain their control over municipal government. As a result of their desperation, widespread violence was employed by many Williams stalwarts, including gangsters Honan and Shanley. According to one newspaper reporter, the legislative council elections of 1904 were distinguished "by the use of torch and pistol in the hands of a lawless and riotous mob," which at one point stole the ninth ward's ballot box. The Williams coalition was successful in electing his candidates to the legislative council, but in many ways it was a hollow victory, for the mayor's image was further tainted by the unseemly tactics employed by his supporters.

At the same time, reformers, emboldened by Williams's loss of prestige, called a mass meeting at which they denounced the mayor for committing election fraud and formed a committee to coordinate anti-administration activities. The committee met with Williams not long after, demanding that he enforce the law. Calculating that Memphians really didn't want a squeaky-clean city, Williams bowed to the reformers' wishes and ordered the police, in the words of historian William D. Miller, "to close all saloons at midnight, even on Saturday, to shut all houses of prostitution and to suppress gambling completely." As Williams thought, a backlash against the reformers emerged when Walker Wellford and Reverend William E. Thompson had several prominent businessmen arrested for organizing an automobile race on a Sunday.[29] However, the laughter that undoubtedly rippled through city hall soon died when gunfire erupted in South Memphis between law enforcement officers and the mayor's political supporters.

With the reform drive seemingly discredited, several vice establishments were quietly opened in the summer of 1904, including a gambling den located on DeSoto Street. At about 6:00 p.m. on July 11, an African American

informant named John Smith reported its existence to magistrate court squire Frank W. Davis. Furious, Davis swore out warrants for the arrest of the building's owners, Harry Hartley and Harry Keene, charging them with "running a house for the purpose of playing for drinks and money." The squire then ordered magistrate deputy John Lawless to serve the writs. John Smith was quickly sworn in to guide Lawless and Deputies Thomas J. McDermott, Houston Mitchell (who was African American), C.W. Shoults and Frank Solly to the establishment. Along the way, Solly abruptly informed the others that he had something else to do and slinked off in the direction of the Memphi Theater, headquarters of gangsters Mike Haggarty and George Deggs.

Arriving at the rear of 42 DeSoto Street, the deputies burst into a dingy, smoke-filled room where, sitting on wooden benches, rows of African Americans were playing games of chance while white proprietors stood watch and collected the money. Customers sheepishly rose from their benches as the deputies pulled their weapons and cried that they were all under arrest. Meanwhile, George Honan, George Deggs, Mike Haggarty and Harry Keene were apprised of the situation (possibly by Deputy Solly) and rushed toward DeSoto Street. The deputies were tying their prisoners together with rope when the gangsters broke in, brandishing pistols. When the lawmen refused their demand to let the prisoners go, Honan and the others opened fire.

A bullet pierced Deputy Mitchell's forehead, killing him instantly, and Deputy McDermott collapsed from severe wounds, which soon took his life. Word of the murders quickly spread through the city, and many Memphians were outraged by the brazenness of the gangsters' actions. Included in that number was Squire Davis, who verbally shook his fist at the Memphis Police Department, as well as at the underworld, when he stated to the press: "I have been solicited time and time again to clear Memphis of these dives, if the police will not do it I shall…The murder of my deputies will not deter me." Mayor Williams also condemned the shooting but then crudely attempted to deflect attention away from his gangster ties by blaming African Americans for the incident. "It is my information that the gambling houses were closed some time ago, but negroes [sic] will shoot craps any where and any time…If they are driven out of the city they go into the suburbs and by congregating together frighten women and children. They will gamble wherever they can find a patch of ground big enough to roll dice."

At first, Honan and the others acted as though nothing out of the ordinary had happened, but faced with mounting pressure from their political allies, as well as growing public indignation, the five gangsters wisely surrendered to the

Sheriff's Department, after which they were unceremoniously incarcerated in the county jail. According to one newspaper reporter, Deggs, Keene, Haggarty, Hartley and Honan did not seem the least bit concerned about the possibility of being indicted for murder but rather acted as if they had merely "taken refuge in a house during a storm after which he would again walk the path of free manhood." As it turned out, there was little reason for them to worry. Of the five, only George Honan was indicted for murder, but he was quickly found not guilty after his defense attorney, Memphis congressman Malcolm R. Patterson, argued that the African American Mitchell deserved to be shot because he was insolent to the white men.

The only real attempt at punishment was directed toward Mayor Williams, who was widely condemned for his long-standing relationship with the acquitted murderer. Shortly after the incident, the ubiquitous reformer Walker Wellford joined forces with police department captain Dabney Scales in calling for Williams's resignation. Their proposal went nowhere, but it did spark the creation of a Committee of Public Safety, which demanded from the mayor a detailed accounting of his plans to rein in the criminal element. In reply, the mayor declared that crime had actually decreased even though the city's population had doubled in size during his administration. However, in order to mollify the reformers, Williams pledged to keep the gambling houses closed and regulate the saloons. His explanation and promise impressed the committee members, who expressed "their admiration for his stewardship as executive head of the city." Nevertheless, the stench of the DeSoto Street murders clung to Mayor Williams and, in the eyes of some, tainted all aspects of local government.

When limited home rule was restored in 1893, the mayor was also designated as chairman of the three-man Fire and Police Commission, which meant that he had a great deal of control over the direction of law enforcement in Memphis. The DeSoto Street incident suggested to a group of local reformers the need for more legislative control over the police department to check the power of the executive. Consequently, the Jackson Club was formed by a group of young lawyers to draft proposals for amending the city charter. Their first step was to secure the support of the Shelby delegation to the General Assembly because any changes to the charter required the approval of the legislature. A state election was scheduled for the fall of 1904, so the membership slated a group of reform-minded nominees for the legislature to challenge the mayor's handpicked candidates. Campaigning on the theme "home rule against one-man power and political bossism," the Jackson reformers defeated Williams's candidates

handily, clearing the way for home rule reform. With the election behind them, Jackson Club members focused on drafting a bill to be introduced when the General Assembly opened early in the next year.

Completed in early January 1905, the bill was quickly presented to the legislature and, after two months of debate, was signed into law in early March. The final version incorporated most of the recommendations made by the Jackson Club, although a few of the most controversial, such as electing the police chief and adopting civil service procedures for the fire and police departments, were not adopted. Nevertheless, the core of their proposals did become law. The most important of these were expanding the size of the Fire and Police Commission and granting the legislative council the power to remove the mayor from office by a two-thirds vote if found guilty of a "misdemeanor." It did not take much to interpret the charter amendments as another defeat for Mayor Williams. Certainly his opponents believed that this was so, and they laid plans to unseat him in the next municipal election, scheduled for the fall of 1905. As the historian William D. Miller wrote, "It was no naïve company of psalm-singers that opposed Williams in the election of 1905, but an organization that already had been successful in one contest and was determined to win another."

For his part, Mayor Williams emphasized his many accomplishments, including annexation, street and sewer improvements and the parks system, while at the same time obscuring the unsavory aspects of his reign. For example, at one political rally Williams declared, "I have greater interest in the development of Memphis and in the welfare of her people, I guess, than almost any man in this community. In spite of this…these assassins of character have gone deliberately to work and used their efforts to try to destroy me and have given your town the black eye all over this country."

As Williams tried his best to dodge his underworld connections, the anti-administration forces met in early October at the Lyceum Theatre, where they announced their platform and introduced their candidates. Nominating local attorney and former State Bar Association president James H. Malone for mayor, the self-styled Independents called for a yearly audit of the city's finances, an open bidding process and the public ownership of utilities in their platform. Electric lights and appliances had become commonplace in Memphis homes and businesses by the beginning of the twentieth century despite the high rates charged by the privately owned Consolidated Gas and Electric and Merchants Power and Light Companies. In order to expand access to electricity and lower rates, progressives believed that the people through their government should own power utilities rather than private interests.

In keeping with this sentiment, the Independents also pledged to defend the rights "of the common people, against corporate influence and organized wealth." Protecting Memphians from organized crime was not mentioned in the Malone Ticket's platform, and this may have signaled to the underworld a flexible attitude toward vice by the Independents. Consequently, leaders of the criminal classes offered their support to the Malone Ticket members, who, although sincere in their desire to reform local government, also wanted to win, and they gladly accepted the gangsters' endorsement.

Dark clouds hung over the city and a misty rain fell as voters headed to the polls on election day. Across several city wards, underworld representatives were out in force, determined to snatch victory for the Malone Ticket regardless of cost. In the fourth ward, for example, gangsters disrupted the polling place located in the back of the Climax Saloon on Monroe Avenue. During voting, someone dropped the curtain that stood between waiting citizens and the ballot box, and a confederate spirited the box away and replaced it with a similar-looking container. A citizen witnessed the switch, and when he challenged the theft, he was beaten around the face as the thief ran to a nearby alley, where Harry Keene was waiting in a buggy. Wrapping the stolen box in a blanket, Keene cracked his whip and sped quickly toward the eastern edge of the city. Others attempted to steal ballot boxes in the second ward, but they were stopped by Shelby County sheriff Frank Monteverde and several armed deputies. When the votes were counted, including those in the fraudulent fourth ward box, Malone easily defeated Williams to become the next mayor of Memphis. In addition to Malone, several other Independents were elected to the legislative council, including the young businessman Edward Hull Crump, who won a seat on the board of public works supervisors.[30] On the surface, Malone's election seemed to suggest that the progressive reformers now had the power to bring businesslike efficiency to local government, regulate big business and ensure the public ownership of utilities. However, the unsavory way in which they attained that power called into question whether Memphis could continue to develop into a progressive twentieth-century metropolis or devolve into a corrupt strife-torn city dominated by criminal gangs.

"WHY NOT VOTE THE OFFICIALS OUT OF POWER?"

O n January 3, 1906, James H. Malone was inaugurated mayor, and he moved quickly to address the growing tax inequity in the city. In 1905, the state legislature passed the Boyle Bill, which gave local government the power to equalize the tax rate across Memphis and thus eliminate the tax differential for suburban residents. Not wanting to anger the wealthy suburbanites, who naturally liked paying fewer taxes, Mayor Williams had previously blocked any attempt by the legislative council to pass an ordinance equalizing the tax rate. A month after his inauguration, Malone introduced an ordinance establishing a uniform tax rate, which was quickly passed by the legislative council. Equalizing taxes resulted in greater efficiency and, along with more precise bookkeeping practices, led to a lowering of the overall tax rate. Once the tax issue was addressed, Malone felt free to pursue further annexation. In March 1909, the General Assembly approved a bill that extended the city boundary to include an important railroad yard, the town of Lenox and a section of Overton Park.

As we have seen, street repair had faltered during the previous administration due to lack of funds. Despite improved accounting practices, there remained a dearth of revenue to adequately pave city streets and add needed sidewalks. In 1907, the General Assembly passed the front foot assessment law, which allowed property owners whose land abutted city streets to request improvements provided that they agreed to pay two-thirds of the cost. Forty-six paving projects were initiated the following year, with the city appropriating $750,000 for the improvements. It quickly

became evident, however, that waiting on property owners to start the process, combined with unwieldy contract negotiations, severely hampered Memphis's ability to pave streets in a systematic fashion. Because of this situation, Malone successfully amended the law to allow local government to initiate improvement projects and tax property owners to pay their portion of the project's cost. This action dramatically increased the amount of repair and paving that took place and provided Memphis with a modern street system for the first time in its history.

Many of the goals set by local progressives had been achieved under the Malone administration, most notably, tax equalization and a modern street system, but progressives were disappointed by their inability to achieve the public ownership of utilities. The same year Malone was elected mayor, the state legislature allowed the city to increase its bonded indebtedness by $10 million in order to construct an electric light plant or purchase an existing one. Despite having the financial means to bring this about, Malone and the legislative council did nothing, which irked many local progressives, most notably public works supervisor E.H. Crump. Declaring that members of the public works board were treated like "schoolboys" by the mayor and police commission, Crump abruptly resigned from the legislative council in September 1907.

As we have seen, Malone owed his office in large part to the underworld that controlled a large bloc of votes and had plenty of money for campaign contributions. Consequently, they expected favors from those whom they helped elect. For example, in the spring of 1906, the police raided the Anchor Saloon on the orders of Vice-Mayor John T. Walsh. The establishment was owned by Mike Haggarty and George Deggs, who demanded an end to such activities. If not, Haggarty promised to expose voting irregularities from the last election. After a time, Walsh publicly denounced the underworld's threat, but the message had been received. Haggarty's saloons were left alone for the rest of Malone and Walsh's term.

The administration was embarrassed further when E.H. Crump was elected to the Fire and Police Commission in late 1907. Moments after he took the oath of office on January 2, 1908, Crump called a special session of the commission in which he ordered Police Chief George O'Haver to close all saloons at midnight during the week and all day on Sunday. "I don't want to be hard on anyone, I simply want to see that the law in this respect is enforced while I am in office and I am going to do my best to see that it is," the new commissioner explained. The other members reluctantly agreed to Crump's demands, and the saloons were promptly closed. Not long after, he personally led raids on several gambling dens alongside nineteen handpicked

special deputies. Naturally, the underworld members, not to mention Mayor Malone, were not pleased by Crump's actions and undoubtedly laid plans to destroy his nascent political career. While the criminal bosses seethed, the progressive commissioner joined forces with a group of reformers working to abolish the current city government.

Urban progressives in many parts of the United States, including Memphis, believed that corruption and waste could be eliminated from municipal affairs through the adoption of the commission form of government. Unlike the mayor/council structure, the commission plan eliminated the traditional splitting of executive and legislative functions into separate branches. Instead, government authority was centralized in the hands of a five-man commission; the men had both executive and legislative responsibilities and were elected at-large. The mayor served as a full member of the board and was also the head of several city departments. The commission sought to create a kind of corporate board of directors that would operate more efficiently than other governments. As he had with the Fire and Police Commission, Crump quickly became the leader of the pro-commission forces. A bill was introduced in the General Assembly to adopt the commission plan, and the young commissioner personally lobbied legislators on the measure's behalf.[31]

Because of his aggressive lobbying, Crump was closely identified with the commission plan when it became law in February 1909, and he used that notoriety to launch his candidacy for mayor in that year's municipal election. Opposing Crump was J.J. Williams, who campaigned heavily in the African American and Irish communities in the hopes of defeating the progressive bloc at the polls. Their combined political weight was not quite enough, however, for on election day Crump defeated Williams to become the first mayor under the commission form of government. During Crump's terms as mayor, he implemented some civil service reform, regulated the street railway and telephone companies and improved public health by inspecting local dairies, licensing midwives and requiring all schoolchildren to have routine medical examinations. He was far less successful, however, in achieving city ownership of the electric power utilities. Under Crump's leadership, the citizens of Memphis overwhelmingly voted to issue bonds to purchase the holdings of the Merchants Light and Power Company, but the two parties could not agree on a price.

While Crump enacted his progressive laws, he also constructed the broadest, and most powerful, political coalition in the history of Memphis. The mayor assiduously courted every major voting bloc in the city, building a base of support that cut across ethnic, racial and socioeconomic lines. Crump

was not far wrong when he declared that his organization was "not composed of any particular faction or class, but of the people of Memphis at large." By the time he left the mayor's office, Crump had laid the foundation for what would become one of the most powerful political machines ever to operate in the United States. Crump's election coincided with the emergence of an African American middle class that had no memories of slavery or the racial violence that had occurred in post–Civil War Memphis. Far more inclined to use their franchise to pressure white leaders than the previous generation, they soon became an important part of the nascent Crump machine.

African Americans had been a factor in local elections since the late 1860s, but their influence had waned by the turn of the twentieth century. This began to change in 1908, when Bert Roddy, an African American bank clerk, began organizing a group picnic. There were no city parks available that could accommodate the expected crowd because there was no law barring African American use of the properties. However, as Roddy and every other black Memphian knew, white violence was a distinct possibility if African Americans set foot on park property. Nevertheless, a large open space was needed, so he approached then mayor Malone for permission to use a park for the picnic. Malone referred him to park commission chairman Robert Galloway, who refused to allow African Americans to congregate in a city park. During their conversation, the chairman did comment in an offhand way that Roddy should petition city government to build a blacks-only facility in Memphis.

Although no doubt angry at Galloway's curt dismissal of his request, Roddy did collect a petition requesting a black park that he presented to the legislative council, which promptly tabled the measure. An accomplished businessman who would soon open a chain of local grocery stores, Roddy took the information gathered during the petition drive and organized the Colored Citizens Association to marshal black voting strength and pressure local government to change its position. Protest meetings were held, and during one such affair, a black Memphian perfectly articulated a strategy that would be employed by the Colored Citizens Association and subsequent African American organizations for most of the twentieth century: "The Negroes of Memphis constitute a sleeping political power. If we don't get our rights under the law, then why not vote the officials out of power?"

When the 1911 city election season began, the Colored Citizens Association employed this strategy with the two men running for mayor, E.H. Crump and J.J. Williams. Meeting privately with both men, association leaders promised to deliver a bloc of votes to the candidate who offered the most support

for an African American park. Crump won the association's endorsement, and the election, when he declared that the "colored citizens of Memphis are undoubtedly entitled to park privileges." In 1913, largely due to Roddy's persistence and Crump's ambition, the city opened a park for African Americans in the Douglass community. The establishment of Douglass Park did more than simply provide a tranquil open space for black Memphians. It proved that the strategy of bloc voting could not only swing a local election but also deliver tangible results to the African American community.

As this revolution in southern politics was taking root in Memphis, a different kind of transformation was occurring in local grocery stores. In 1916, Clarence Saunders opened his first Piggly Wiggly store at 79 Jefferson in downtown Memphis. Unlike other grocery stores, which relied on clerks to hand customers their desired goods, Saunders placed all items within easy reach of the consumer. As he explained in his advertisements:

> *A customer wants five pounds of granulated sugar put up in a cloth bag. She is in a hurry, so she runs into the Piggly Wiggly and helps herself. She pays the cashier and away she goes. Another wants several articles, so she fills a basket, pays the cashier and off she goes. Every article in the Piggly Wiggly will be put up in convenient packages ready for sale.*

This concept was quickly embraced by the shopping public, and by 1921 there were 615 Piggly Wiggly stores in forty states, with combined sales of $60 million. Saunders's version of self-service not only improved the Bluff City's economy, but it also influenced the way stores were organized and changed how Americans shopped.

Meanwhile, the criminal gangs continued to exert a great deal of power in the Bluff City, especially after the State of Tennessee outlawed the sale and manufacturing of liquor in 1909. As discussed previously, Crump had attacked the underworld as police commissioner, and when he became mayor he continued his crusade, ordering law enforcement officials to increase patrols, which led to a higher number of arrests. However, Crump soon determined that Memphians did not want a complete prohibition of vice and, like his predecessors, found it expedient to cooperate with the underworld. For example, the police did all they could to protect George Honan's gambling and saloon interests from the prying eyes of nearby residents. In 1913, fed up with the raucous behavior and constant gunfire at Honan's place on North Second Street, citizens wrote to the mayor and Police Commissioner Robert Utley demanding that it be "removed out

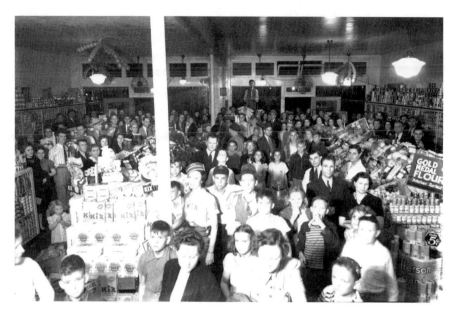

Stores such as the Sel-Rite grocery on Jackson Avenue recognized the popularity of Clarence Saunders's version of self-service and adopted it for their own business operations.

of our neighborhood." The police officer investigating the matter had no sympathy for Honan's neighbors, however, describing them as "soreheads" who were in league with rival gamblers. In his badly misspelled report, Sergeant J.S. Pruett wrote that others "have bin doing the Shooting, and make it apeer that it comes from Honans place." The mayor apparently had little sympathy for them, either, for there is no evidence that action was taken against the underworld establishment.

Crump also sided with gangsters over the issue of prohibition. Denouncing the measure as an unfunded mandate that burdened local government, the mayor explained that "the state is endeavoring to make Memphis enforce the law which the legislature passed over the protest of the majority of voters of the city." They might not have constituted a majority, but there were many Memphians who wanted prohibition enforced. Concerned citizens formed the Law Enforcement League and joined with the Anti-Saloon League and the Women's Christian Temperance Union in pressuring Crump to enforce the statute. When he refused, they turned their attention to Nashville, where they soon found an ally in Governor Thomas C. Rye.

A staunch prohibitionist, Rye signed into law the Elkins Ouster Bill, which allowed for the removal of any public official after a complaint was lodged by any law enforcement representative or at least ten citizens that the said

official was not properly carrying out his responsibilities. In November 1915, eleven months after the ouster law took effect, Crump was removed from office and streets commissioner George C. Love was appointed acting mayor. Although his ouster was caused by his nonenforcement of the prohibition statute, Crump blamed "corporate interests" for his removal from an office to which he was legally elected. Vowing revenge, the former mayor hoped to continue directing city affairs through his loyalists on the commission. The *Commercial Appeal* was delighted at this turn of events, declaring Crump's removal as "the ending of a chapter in a story of rotten politics."[32] Despite the newspaper's obvious glee, the mayor's ouster did more than derail one man's political career; it created a power vacuum that hamstrung local politics for years to come.

As a result of this instability, three men served as mayor from late 1915 until August 1918. The strain of leadership became too much for acting mayor Love, who abruptly resigned in February 1916. Thomas Ashcroft was appointed in his place and served until August 1917. Like Love, Ashcroft was a Crump loyalist who, when he became mayor, declared, "So long as I occupy the mayor's office I shall consider [Crump]…the real mayor of Memphis." However, when Crump took Ashcroft at his word and began to dictate policy decisions, the mayor bristled at his interference and lashed out by removing several Crump stalwarts from their city posts. In retaliation, Crump began ouster proceedings against Ashcroft, which prompted his resignation.

Anti-Crump Democrat Harry Litty was then chosen to serve as mayor until August 1918, when a special election was finally scheduled to select Crump's successor. Stalemate between the Crump and Litty forces prevented local government from accomplishing anything substantial for its citizens, and this trend continued when Frank Monteverde was elected mayor in August 1918. Crump had nominally supported Monteverde in the election, but the two leaders soon quarreled when the new mayor raised the tax rate by sixty-two cents. As discussed previously, grassroots organizing, forming committees and holding mass meetings were commonplace in Memphis whenever citizens felt that local government was careening out of control. This trend continued in 1919 when a group of "business and professional men, suffragettes and progressives…formed a nonaligned political organization called the Citizen's League to challenge the 'juggernaut of graft and sinister politics.'"

Surveying available candidates who would be acceptable to its progressive-minded membership, the league's executive committee asked wholesale grocer Rowlett Paine to run for mayor. Although a political novice, Paine was attractive to the executive committee primarily because of his Rotary Club

involvement and natural modesty. True to form, Paine initially demurred but changed his mind when a mass meeting of the Citizens League endorsed his nomination. Opposing him were J.J. Williams, who again sought to recapture the mayor's office, and County Commissioner William J. Bacon, who represented Crump's county organization. Bacon's candidacy did not last long, however, owing to his withdrawal in early October, but Williams fought tenaciously to reclaim his former glory.

As Paine's ticket gained traction with the Memphis electorate, Williams attempted to derail the grocer's candidacy by charging that during World War I he had gouged consumers by increasing the price of sugar beyond the ability of many housewives to pay. The accusation could have dealt a serious blow to the Citizens League, owing to the fact that Tennessee had just granted women the right to vote. Instead of gathering a host of facts and figures to refute the charge, Paine made a joke of it. Posters were printed and distributed throughout the city showing Paine with his lovely six-month-old daughter, with a caption reading: "This is Sugar Paine…The only one who Controls Paine." No doubt many Memphians were still chuckling when they went to the polls and elected the wholesale grocer mayor by a 2,700-vote majority. Women in particular heavily supported Paine, who, to the surprise of many, even received a last-minute endorsement from the Crump organization. Although this endorsement may have helped a little, the most important reason for Paine's victory was voter anger over the dysfunctional politics that had reigned in Memphis for the previous four years.[33]

The most pressing issue facing the incoming administration was the woeful state of the city's finances. Previous mayors had been unwilling to raise taxes, so several city services had languished due to declining tax revenue. This was especially true in the city school system, where teacher salaries were so ridiculously low that educators were contemplating a strike. Mayor Paine, alarmed at the financial picture, convinced the commission to increase the school tax, which improved the city's overall financial situation and provided an increase in teacher salaries. However, there was a glaring omission in Paine's reform efforts. The mayor chose to ignore the plight of black educators and only give pay increases to white teachers. African American schoolteachers routinely received lower pay than their white counterparts, and the mayor's callous decision no doubt angered them further. Sensing an opportunity to needle a political rival, Crump lashed out at Paine's action, declaring that black teachers are "entitled to better pay on account of the increased cost of living which has not been confined to a single race."

The pay raise averted a teachers strike, but there was no money left to improve the wages of other city employees, especially firefighters, who formed a union and demanded salary readjustments for the rank and file. Negotiations between Mayor Paine, Fire and Police Commissioner John B. Edgar, chamber of commerce president Robert Ellis and union representatives dragged on for several months before finally ending on July 13, 1920, without an agreement in hand. Paine and Edgar offered to purchase additional equipment and provide a clothing allowance, but the city charter set the pay rate, and only the state legislature could change it. Not satisfied with the city's offer, union officials handed Edgar a letter containing the resignations of virtually the entire fire department effective at noon on July 16. In the wake of the resignations, a mass meeting of citizens was hastily called by Paine and Edgar to recruit volunteers to man the fire stations. Seven hundred Memphians answered the mayor's call—many more than were needed to ensure adequate fire protection for the city.

When noon arrived, the professionals walked out of their stations and were immediately replaced by volunteers, who checked the equipment and waited for an emergency call. Within a short time of assuming its new duties, the volunteer force successfully extinguished two fires, while at the same time other Memphians patrolled their neighborhoods looking for fire hazards. Meanwhile, the city's two National Guard units were scheduled to attend the state's annual encampment in Knoxville, but they were ordered to stay by General E.B. Sweeney after conferring with Paine and Edgar. The local troops were soon joined by an infantry company and a machine gun unit from Knoxville. The threat of a major conflagration sweeping through the city soon diminished with volunteers stationed at all the firehouses and soldiers prepared to assist them.

The union did not anticipate local government taking such a firm stand against the firefighters nor the enthusiastic support Paine and Edgar received from the citizenry. Presumably it hoped that empty fire stations, and the fear this would create in the populace, would force city government to bow to their demands. Instead, Paine and Edgar were emboldened in their stand and refused to negotiate when the union requested a ten-day cooling-off period during which the men would be allowed to return to their jobs. "The former members of the fire department...preferring to obey the dictates of an organization to which they belonged, rather than to perform the duties imposed by law, have resigned in a body, and attempted to leave the city unprotected against fire. Their resignations have been accepted." This ended any hope of reconciliation between the union and city government, and the strike collapsed.

By the end of the month, a full complement of new firefighters had taken the strikers' place, and the National Guard had been ordered out of the city. As the newly hired firefighters manned their posts, Mayor Paine no doubt felt a sense of accomplishment. He had preserved the principle that public employees did not have the right to strike and prevented disorder by swiftly organizing volunteer firefighters and placing National Guard troops at key points in the city. The majority of Memphians applauded Paine's handling of the affair, but the opposite was true for many city workers, especially members of the police department. To them, the mayor had showed his untrustworthiness, not to mention a certain amount of contempt for the right of public employees to bargain collectively, and they were unwilling to ever trust him again.

Shortly before the fire strike, in the spring of 1920, a local business had announced plans to build a garage at the corner of Union Avenue and Waldron Street. Located in a neighborhood of stately homes, the garage threatened to spoil one of Memphis's most fashionable neighborhoods. Nearby residents were livid at the prospect of a commercial enterprise in their midst, so they inundated Mayor Paine with letters and petitions demanding that the city block construction. Unfortunately for them, the city charter did not grant local government any authority to restrict businesses. As he read message after message, Paine knew that he could do nothing but decided to hold a public hearing to "let the people talk." The residents and their attorney described in detail the damage that would be done to the neighborhood if the garage was allowed to open. "You're right but what do you propose I do about it?" the mayor asked. When the citizens had no reply, Paine explained that what "we need is a city plan. We need to have the property zoned for different commercial and residential use."

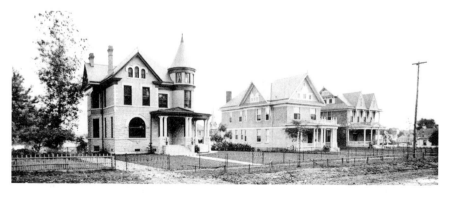

During the 1920s, the stately homes on Union Avenue were threatened with commercial encroachment, which led to the adoption of zoning regulations for Memphis.

Armed with the support of Union Avenue residents, the mayor appointed a city planning committee that, after studying the situation, recommended that the commission hire noted city planner Harland Bartholomew to investigate and offer planning guidelines to the city. At the same time, Paine and the commission convinced the state legislature in 1921 to grant Memphis "the power to zone, and to regulate the uses of land, the height, area, bulk and location of buildings within such zones." With this legal sanction, the unofficial planning committee became the City Planning Commission, and on November 7, 1922, it passed a zoning ordinance that became the cornerstone of Bartholomew's comprehensive city plan for Memphis. Completed in 1924, the plan called for widened and extended streets, improved railroad grade crossings, an expanded river terminal and additional recreational facilities. Memphis was also divided into zones, which established height and area restrictions on building construction and divided commercial and residential development into separate sections of the city.

The city plan was widely praised by many Memphians, but not by all. In the spring of 1924, the Spencer-Sturla funeral company purchased a home at the southeast corner of Union Avenue and LeMaster Street for use as a mortuary. When the funeral home began construction in violation of the ordinance, a suit was brought against it, and the company was fined fifty dollars by the city court. Appealing the decision, the case made its way to the Tennessee Supreme Court, which upheld the principle that municipal zoning was constitutional under state law. The struggle for city planning did much to improve the quality of life in Memphis and strengthened the city's neighborhoods. The example set by the Union Avenue protesters established a template that would be adapted by other neighborhoods seeking to arrest development threatening their property. Unfortunately, it did little to save the homes on Union Avenue. In 1930, the City Planning Commission allowed commercial development between Bellevue east to Cooper, which destroyed the integrity of the neighborhood. Within twenty years, the majority of stately homes on Union were gone, and the street became a major commercial corridor, with shops and businesses dotting the landscape.[34]

Crime remained a serious problem in Memphis during the 1920s, even though most of the old Irish gangsters were dead. Mike Haggarty was killed in his saloon when he opened fire on a drunken patron, and George Honan was shot to death after murdering a young woman during a pistol duel. Vice continued, of course, and the Irish mob's criminal empires were soon taken over by Italians such as Nollo Grandi, who controlled the numbers racket, and John Bellomini, who was a leading bootlegger and narcotics peddler.

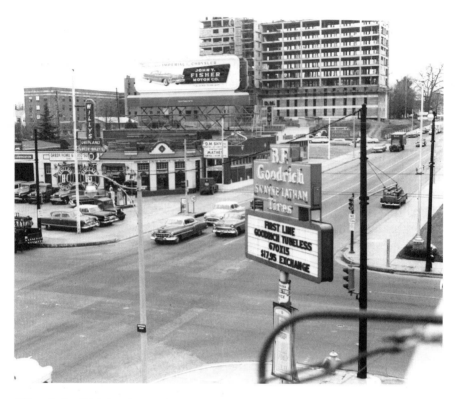

Although the 1924 city plan restricted commercial development in residential neighborhoods, it came too late to protect Union Avenue as seen in this 1957 photograph.

To make matters worse, the homicide rate increased dramatically, which led the statistician for the Prudential Insurance Company, Dr. Frederick L. Hoffman, to declare Memphis the murder capital of the United States. In 1925, during his second term, Paine created a crime commission made up of the mayor, police commissioner and assistant city attorney. Designed to better coordinate the city's law enforcement efforts, the commission partnered with the American Institute of Criminal Law and Criminology to study the situation and make recommendations to reduce the rate of violent crime. In their study, institute researchers concluded that "the greatest evil of Memphis from a criminal standpoint is its transient, pleasure-seeking population…Thus a demand is created in Memphis for vice and for intoxicating liquor and the purveyors of intoxicating liquor and of vice and immorality seek to meet the demand…The young men and women of Memphis and the surrounding area see the law openly flouted and lose all respect and all reverence for law and order and good

government." Except for the last sentence, this is exactly what J.J. Williams and E.H. Crump had been saying for years. Understanding the root causes of crime in Memphis was no doubt instructive but did little to curb the power of the criminal gangs.

The pervasiveness of the underworld was clearly revealed when prohibition agents raided John Bellomini's grocery store and found a ledger book containing the names of fifty-one police officers, with dollar amounts listed by each entry. Mayor Paine requested a federal grand jury investigation, but Judge Harry Anderson refused to become involved in a local matter. The evidence against the officers was hardly conclusive, but that fact did not deter Paine, who, in conjunction with Police Commissioner Thomas H. Allen, charged forty-one officers with "inefficiency, incompetency, and conduct unbecoming an officer." A civil service trial board was quickly convened, but the men were exonerated and allowed to return to duty. Unfortunately for Mayor Paine, the 1927 municipal election was just getting underway as the Bellomini affair became public. Challenging Paine was attorney and former state legislator Watkins Overton, who headed the "People's Ticket" organized by E.H. Crump.

Paine was at a considerable disadvantage when he launched his bid for a third term. Many city employees felt betrayed by his suspension of police officers without reliable proof of their guilt, while at the same time middle-class reformers felt that he had not done enough to root out corruption in law enforcement. However, the greatest threat to Paine's reelection was the burgeoning strength of the African American vote. In 1927, the African American–led West Tennessee Civic and Political League organized a massive voter registration drive that increased the number of eligible black voters to eleven thousand. Of those African Americans who were registered, few were inclined to vote for Paine. Many remained angry over his refusal to raise the pay of African American schoolteachers, and that number grew when the mayor built a crematory near the city's black high school in spite of widespread neighborhood protest. Correctly determining that the WTCPL was in opposition to his candidacy, Paine denounced it as "the greatest menace to white supremacy in this city since reconstruction days." Shortly thereafter, the West Tennessee Civic and Political League formally endorsed the Overton/Crump ticket. Its endorsement was the final blow to Paine's doomed reelection bid. On election day, Paine received a mere 6,948 votes, while 19,548 ballots were cast for Overton.[35]

The Paine administration had accomplished a great deal since 1920. In addition to improving some teacher salaries, adopting a city plan for

Memphis and upholding the principle that public employees did not have the right to strike, Paine appointed a woman to the juvenile court bench, built the city auditorium, secured the University of Tennessee medical school for the Bluff City and reorganized the police department. However, as the Bellomini scandal suggests, Paine did little to curb the overall power of the underworld. While Rowlett Paine nursed his wounded pride and Watkins Overton savored his victory, the criminal gangs waited expectedly for the new mayor's inauguration to see what kind of deal they could make with their old ally E.H. Crump.

"We Cannot Stand Still"

The denizens of the Memphis underworld expected that the new administration would wink and look the other way as they continued to operate their gambling, liquor and prostitution rackets. Describing themselves as "paid up" members of the Crump organization, local racketeers had every reason to believe that government officials would not prevent them from meeting the public's insatiable desire for vice. That belief was soon shaken, however, when, shortly after their inaugurations in January 1928, Mayor Overton and Fire and Police Commissioner Clifford Davis ordered officers to raid several gangland havens, where more than one thousand gallons of illegal whiskey were seized. Underworld leaders demanded an end to the raids and called for Davis's resignation, but Overton refused to bow to their pressure. In 1930, the city broke up the loan shark racket by prosecuting its organizers for violating the Small Loan Act, and police successfully raided an opium den on Horn Lake Road. These actions were, for the most part, little more than an attempt to placate the middle-class reform element in the city rather than to crush the underworld. No doubt Crump and Overton hoped to provide just enough law and order to satisfy the reformers while at the same time not angering the city's "pleasure-seeking population." As we shall see, that position would soon become untenable.

For the first year and a half of Overton's first term, the city's finances were in reasonably good shape, so much so that Memphis was able to construct a municipal airport, which greatly improved the city's economy. The *Commercial Appeal* declared in 1928 that Memphis "is growing. Business is good. The

people are contented and reasonably prosperous." As this quote suggests, the Memphis economy was generally sound in the 1920s, with several industrial concerns, most notably Ford Motor Company, employing thousands of workers who collectively took home $16,712,000 in wages each year. Many lumber mills were also located in the Bluff City and produced millions of feet of cut hardwood lumber each year. And Memphis was also the nation's largest inland cotton market, which meant that the city's prosperity was largely tied to an economically volatile agricultural commodity.

When the stock market crashed in October 1929, precipitating a series of economic downturns that created the Great Depression, there were few immediate effects in the Bluff City. It wasn't until cotton prices plummeted in 1930 and 1931 that the Depression came to Memphis. As prices fell, industries and merchants that serviced the cotton trade reduced their workforces, leading to widespread unemployment in the Bluff City. Ten thousand Memphians were out of work by December 1930, and less than two years later, a full 14 percent of the workforce was unemployed. Local government attempted to coerce property owners into paying their taxes, but the plan soon backfired as impoverished owners launched a series of protest demonstrations that disrupted city commission meetings and forced the government to abandon its collection drive. Consequently, the city reduced expenditures, which left it with almost no revenue to help destitute Memphians.

Despite this lack of funds, the city did create the Mayor's Commission on Employment and Relief, which distributed food and clothing to the needy and provided temporary employment at a city-owned wood yard. In the spring of 1930, Mayor Overton successfully convinced President Herbert Hoover to increase federal flood control work on the Mississippi River at Memphis, which did prevent some workers from becoming unemployed. These efforts, however, did little to improve the dismal state of the local economy.

Although not apparent at the time, a corner was turned for Memphis when E.H. Crump endorsed New York governor Franklin Delano Roosevelt for president in 1931. The following year, the Memphis leader worked assiduously to secure the Democratic nomination for Roosevelt and, after that was achieved, led a masterful campaign in Tennessee that helped FDR defeat Hoover in the November election. When Roosevelt was inaugurated in March 1933, Crump attended the festivities as a member of the U.S. House of Representatives representing Tennessee's Tenth Congressional District. In the Seventy-third Congress, Crump distinguished himself as a staunch supporter of FDR's New Deal by voting for every piece of legislation introduced by the president during his first one hundred days in office.

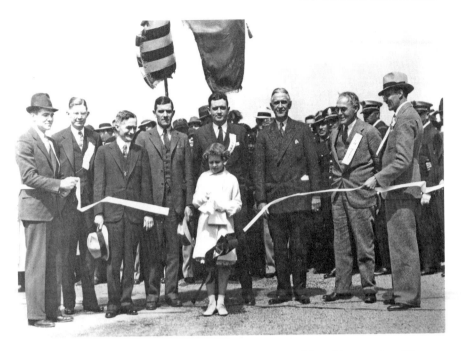

During the Great Depression, the federal government gave Memphis more than $6 million for construction projects including Riverside Drive, which was completed on March 28, 1935.

The support Crump gave to both Roosevelt's campaign and his legislative agenda paid huge dividends for the Bluff City. About $15 million was provided to local authorities by the federal government for welfare and relief programs, and more than $6 million was funneled to Memphis for construction projects. During the 1930s, "street paving and sewer construction were expanded, while major building projects like John Gaston Hospital, Crump Stadium, and Riverside Drive transformed the landscape of Shelby County." By relying on federal funds to combat the Depression, Memphis was able to keep its debt low, along with its tax rate. Of course, this also meant that local government refused to allocate its own resources to help those in need. As one federal official commented:

> *Memphis gave the distinct feeling that a warm welcome was extended to government concerning itself with the plight of the unemployed, and paying the bills—as long as it is the federal government. The local city and county government thus also welcomes absolution from responsibility—moral or financial.*[36]

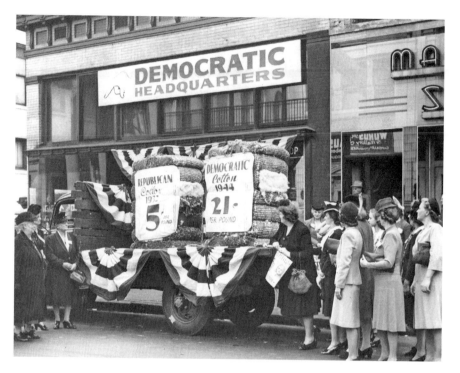

The political machine controlled by E.H. Crump strongly supported the presidency of Franklin D. Roosevelt.

Meanwhile, some of those who had jobs, and thus money to spend, continued to patronize the underworld's brothels, gambling dens and saloons. Except for occasional raids, such as the ones that took place in early 1928, the gangs were left alone so long as they did not threaten either the Overton administration or the Crump organization. However, when *Collier's* magazine published an exposé on Memphis crime in 1935, Mayor Overton and Crump felt they had no choice but to move against their old "friends." The article, entitled "Sinners in Dixie," concluded that "it is upon commercialized vice that the burden of paying its overhead has been placed by Congressman Crump's political organization."

Apoplectic, and probably a bit embarrassed, Overton, Davis and Crump ordered a sweeping assault on known criminal hideouts. Gambling houses were boarded up, liquor supplies were seized and prostitutes were carted off to jail. The racket that received the lion's share of attention was the illegal lottery known as policy. The most popular form of gambling in Memphis, policy employed thousands of people who handled at least fifteen thousand bets every day. Customers usually paid no more than fifteen cents for the

privilege of choosing three numbers between one and seventy-eight. Each day, policy racketeers selected twelve numbers that entitled those holding the winning tickets to collect a sum of money.

Although these raids put a dent in local criminal activity, the gangsters expected the lid to be lifted as it always had before. But it wasn't. Instead, police officers tightened their grips, striking at establishments that in years

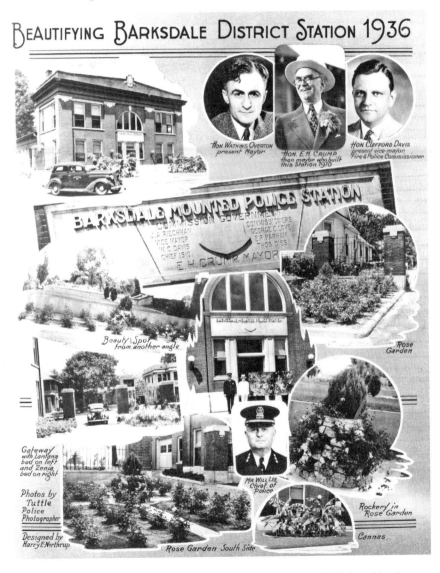

Collier's magazine published an exposé on Memphis crime in 1935, which forced local leaders to move against the city's gambling rackets.

past had been protected. In June, the department's Purity Squad besieged the homes of madams "Dutch Mary" Sherron and Martha Hunter, both of whom were arrested for running disorderly houses, along with several young women, who were charged with vagrancy. At the same time, harassment continued against known bootleggers and gamblers. The situation grew so bad that the underworld sent policy kingpin Nollo "Red" Grandi to meet with city officials; he pleaded with them to ease up. To his dismay, they replied that policy games would never be reopened in Memphis.

A major turning point in the war against the underworld came in early 1939, when the Tennessee General Assembly repealed statewide prohibition. The new law gave localities the authority to decide by referendum to allow or prohibit the sale and manufacture of intoxicating liquor. In May of that year, Shelby County voters overwhelmingly agreed to the legalization of alcohol, which ended prohibition in the Bluff City. Criminal gangs quickly saw their bootlegging orders dry up as Memphians flocked to purchase liquor from government-licensed distributors. The end of prohibition dealt a crippling blow to the underworld and helped launch a major offensive in the city's long war against organized crime.

For years, Mayor Overton and E.H. Crump had worked as equals, with each taking the other's advice and both careful not to offend his ally and friend. This began to change in 1937 when the two squabbled over the city's handling of refugees when the Mississippi River flooded its banks. The following year, Crump became jealous when Overton successfully negotiated the purchase of the Memphis Power and Light Company to create a publicly owned electric utility. When he learned that the purchase did not include the company's gasworks, Crump ordered his loyalists on the city commission to reject the agreement. The former mayor and congressman then took personal control of the negotiations and, after four months, secured electricity and gas for $17,360,000 in February 1939. Stung by Crump's behavior and wanting to escape his orbit, Overton quietly canvassed local ward organizations and civic clubs to determine whether he could run as an independent in the upcoming municipal election. When the mayor uncovered only tepid support, he withdrew from the race, vowing that he would "never bow my knee to any tyrant. I will never raise my hand in the Nazi salute to any dictator."

With Overton off the ticket and purged from the organization, Crump slated Congressman Walter Chandler to succeed Overton. State law prohibited office holders from running for a second position, so Chandler would have to resign his seat in Congress in order to run for mayor.

Ordinarily, this would not be a major issue, but 1939 was not an ordinary year. Europe was plunged into war on September 1, when Nazi Germany invaded Poland. As required by law, President Roosevelt issued a neutrality proclamation that prohibited the sale of arms and munitions to England, France, Germany, Poland and the Soviet Union. Wanting to repeal the Neutrality Act of 1935, the president called Congress into special session, which meant that Walter Chandler was needed in Washington to vote for the administration's measure. Crump still wanted Chandler to serve as mayor, so he announced that he would run in Chandler's stead and, if elected, pledged to serve only as long as it took to tender his resignation.

The 1939 municipal election was essentially a referendum on Crump, and voters overwhelmingly approved of his leadership by casting 31,825 ballots for him. This large turnout was remarkable given that Crump was unopposed and did little campaigning save for a large event held for white Memphians at the fairgrounds. At midnight on January 1, 1940, Crump was inaugurated at a downtown train station so that he could attend the Sugar

Political boss E.H. Crump was inaugurated mayor at midnight on January 1, 1940, so he could attend a football game in New Orleans.

Bowl football game in New Orleans later that day. After taking the oath, Crump promptly resigned, and the city commission appointed Chandler mayor the following day.[37]

Shortly after taking office, Mayor Chandler and Police Commissioner Joseph Boyle expanded the city's war on crime by ordering police to shut down all brothels and arresting the city's numerous bookmakers. Anti-gambling measures passed by the city commission included outlawing bingo, pinball and slot machines, as well as wagering on sporting events. Boyle also took steps to uproot corruption in the police department. When he learned that several brothels had reopened under the protection of the Purity Squad, Boyle dismissed the captain in charge. When asked about his law enforcement drive, Boyle matter-of-factly explained, "We're just enforcing laws." Meanwhile, the national press was astounded at how effectively Memphis was prosecuting its war on crime. For example, a reporter for *Time* magazine wrote, "Last week Memphis had the cold-water blues. Gone from hotel lobbies were the expectant blondes. Brothels were closed; their staffs had fled. Bookies had shut up shop."

While many Memphians applauded Chandler and Boyle's efforts, not everyone was pleased. In 1941, the American Social Hygiene Association sent an investigator to report on "commercialized prostitution conditions" in the Bluff City. During the course of his inquiry, he captured the attitudes of many Memphians frustrated with the severity of law enforcement: "To illustrate how 'strict the law [police] is' one soldier related an incident which occurred last Saturday night in a beer parlor. He said: 'A few soldiers were in there with girls police came in [and] took the girls away. Girls were held for examination, that's how hot this town is.'"

Along similar lines, a local businessman reported that "if a man is caught with a woman he's fined $51.00, she's fined $51.00 and the proprietor of the hotel or place who rented them a room is fined $51.00. If a person is caught going more than 30 miles an hour there's a fine, passing a red light, a fine. Blowing your horn is a fine and brother they sure pour it on."

Although many Memphians felt frustrated and inconvenienced by strict enforcement of laws, it did have the desired effect. Because of the two major offensives launched in 1935 and 1940, the underworld, which for more than sixty years had held a great deal of power, ceased to influence the political life of the city. Of course, individual acts of lawlessness continued, but it is not an exaggeration to state that organized gambling, liquor and prostitution rackets had disappeared from the streets of Memphis by the end of 1940.

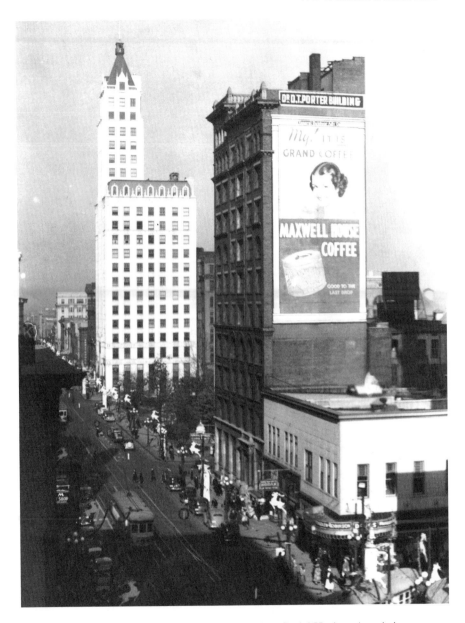

Downtown Memphis about the time that the American Social Hygiene Association reported on "commercialized prostitution conditions" in the Bluff City.

About the same time that the city began its law enforcement drive, President Roosevelt, shocked by the defeat of France by Nazi Germany and concerned about growing friction with Japan, established the National Defense Advisory Commission to encourage the creation of war-related

As Memphians walked by the corner of Main and Madison on the afternoon of September 26, 1940, they heard the latest headlines being shouted by a newsboy.

industries and improve the nation's military readiness. Shortly thereafter, Tennessee governor Prentice Cooper formed the State Advisory Committee on Preparedness, which included Mayor Chandler as a key member. Chandler's knowledge of the federal bureaucracy combined with the political prowess of the Crump organization gave the Bluff City an enormous advantage in securing military installations and defense-related industries. This was confirmed when, shortly after Chandler's appointment, a smokeless powder manufacturing plant was built in rural Shelby County near Memphis and the Kimberly-Clark Corporation built a large plant in the city to manufacture cellu-cotton for defense industries. By the end of 1940, not only had two important defense industries been established in Memphis, the War Department had also headquartered the Second Army in the Bluff City to oversee the training of 500,000 officers and men in military bases across Tennessee.

The city had thus become an important defense center by the time the United States officially entered the conflict in December 1941. Local industry exploded during the war years: airplane engines were built at the Ford Motor plant, rubber life rafts were manufactured at Firestone, Pidgeon-Thomas constructed self-propelled invasion boats, Quaker Oats produced a synthetic rubber compound and army bomber wings and fuselages were

Main Street and McCall Place in April 1940. Memphis played an important role in the nation's defense preparations in the years leading up to America's involvement in World War II.

created at Fisher Aircraft. In addition to the Second Army headquarters, several important military installations were built in or near the Bluff City, including an army quartermaster supply depot, a naval air station in nearby Millington and the one-thousand-bed Kennedy Army Hospital.

Even more importantly, 40,000 men and women from Memphis and Shelby County served in the armed forces during the Second World War, and 662 of them had been killed or were missing by the conflict's end. Included were many African American Memphians who, despite widespread discrimination, did all they could to participate in the war effort. For example, Captain Luke Weathers flew with the famed Tuskegee Airmen and was awarded the Distinguished Flying Cross for shooting down seven Nazi aircraft, and Captain Jesse Turner participated in the invasion of Italy and was awarded the Bronze Star.[38]

Meanwhile, back in Memphis, African Americans faced an increasingly hostile city government. This attitude was clearly revealed in a letter Crump wrote Congressman Davis: "We have been mighty good to the negroes—helping them as you know in many, many ways, and we will continue to do the right thing; but they must know there is a limit." White opposition meant little to those African Americans who were determined to resist oppression in any way they could. One such black Memphian was Lewis Harold Trigg who, in 1942, visited a local employment office to inquire about a job in a defense plant. While there, he refused to take off his hat while in the presence of a white female. As a result of this defiance,

Trigg was arrested for disorderly conduct. To many white Memphians, behavior such as Trigg's was intolerable; Mayor Chandler reported that he found "a rather deep undercurrent of resentment by reputable white people against the growing insolence of the negroes."

At the same time, city leaders were concerned that this so-called insolence would lead to violence. When rumors spread across the city that African Americans were planning an uprising, Chandler issued a strongly worded statement urging "those who have received and passed on the unfounded rumors will correct the erroneous reports, and will disabuse their own minds of any supposed unrest among the people of our city. We have a loyal and patriotic citizenry." Local officials were not overly concerned with the possibility of black violence, but they were not as confident about the white population. "There's a lot of mean white folks down here. White folk who don't like colored people…if anything happened to my colored people—whom nobody likes any better than I do—why I'd feel awful," Crump condescendingly replied during an interview with a reporter.

As a result, the city sometimes went to extraordinary lengths to keep these "white folk" from giving in to their meanness. Perhaps the best example came in May 1943 when the city banned performances of Metro-Goldwyn-Mayer's all-black musical *Cabin in the Sky* from all whites-only movie theaters in Memphis. The reason given was to prevent white Memphians from viewing any film "in which an all negro cast appears or in which roles are depicted by negro actors or actresses not ordinarily performed by members of the colored race in real life" in order to preserve "the public peace from outbreaks of violence due to racial prejudices." This is not to say that city government was only concerned with white people. As the Lewis Harold Trigg incident suggests, they were equally concerned with black militancy.

In the same year as the *Cabin in the Sky* affair, A. Philip Randolph, president of the Brotherhood of Sleeping Car Porters and the nation's most recognizable black civil rights leader, was invited by local union officials to speak in Memphis. In 1941, Randolph had organized a march on the nation's capital to protest discrimination against African Americans in war industries and the military. The threat of this march forced President Roosevelt to issue Executive Order 8802, which prohibited any "discrimination in the employment of workers in defense industries or government because of race, creed, color, or national origin." Randolph's skill in outmaneuvering a consummate politician like FDR made many white Americans rather nervous, including E.H. Crump.

Main Street in April 1943. Memphis's economy blossomed during the Second World War, and local leaders took steps to maintain the city's position as a southern industrial center after the war ended.

When city and county officials learned of Randolph's scheduled visit, they met with several African American leaders to pressure them into canceling the event. Echoing Crump's views, Shelby County attorney general Will Gerber declared that "we have some bad whites and bad negroes here" and a violent incident might be sparked if Randolph gave an "inflammatory" address.

"I think you are seeing ghosts, Mr. Gerber, I don't think anything will happen," replied Booker T. Washington High School principal Blair T. Hunt.

Gerber snapped back, "We are in a position to know what we are talking about." Bowing to their wishes, local union official H.F. Patton agreed to cancel Randolph's appearance.

The black community may have retreated in the face of white hostility, but it hardly surrendered. In the spring of 1944, Randolph was again invited to Memphis by the local chapter of the American Federation of Labor, and this time Crump and his lieutenants failed to block his appearance. During his speech, Randolph castigated the Memphis leader, declaring that Crump had "out-hitlered Hitler" when his earlier appearance had been canceled.

99

"Negroes today want every right, privilege and immunity enjoyed by any other citizen regardless of race or color. Not only do they want these rights but they are determined to fight for them, Crump or no Crump," the labor leader explained to an integrated audience at Beale Avenue First Baptist Church.

Crump was furious, and he wasted little time in lashing out at both Randolph and black Memphians: "If the negroes of this community or any whites insist on these imported rabble rousers, creating hatred, they might as well make up their minds to abide by the consequences." They were not long in coming. Six days after Randolph's speech, the Memphis Fire Department inspected Beale Avenue Church and condemned the property as a fire hazard.[39]

When the war ended in August 1945, Memphis was a far different place than it had been in 1941. The city's economy had blossomed during the war, and Memphis leaders hoped to maintain the city's position as a southern industrial center. One of the most important decisions made in the early postwar years was to seek federal funds to develop an industrial harbor on the Mississippi River near downtown Memphis. Opened in 1955 on President's Island, the harbor attracted such major industries as Sinclair Refining, Cargill, Mid-South Chemical and Commercial Barge Lines, Inc., all of whom took advantage of the area's combination river-rail-truck terminal and 7,800 acres of available storage space. Memphis continued to reap the economic benefits of the industrial harbor well into the twenty-first century. In 2003, 18 million tons of freight passed through the terminal, and by 2005 the island contained 110,000 square feet of warehouse space. Despite the best efforts of city leaders, several defense plants did close after hostilities ceased, but the city's important manufacturing concerns—Firestone, International Harvester and Pigeon-Thomas—successfully converted to peacetime industrial production. At the same time, the naval air station and the army quartermaster depot remained in operation, offering meaningful employment to Memphians until the end of the Cold War in the 1990s.

In Memphis, residents totaled 412,400 people when the war ended, and that number had increased to nearly 483,000 by 1950. The city's infrastructure strained under the weight of this population explosion, and as a result, city leaders proposed to pay for needed improvements by issuing $25 million in bonds. In newspaper advertisements, city leaders argued that it was imperative to pass the bond referendum: "We cannot stand still...we must either go forward or backward. We must either keep in step with other progressive American cities and counties or stand on the sidelines and watch the parade of progress go by." At least 93 percent of votes cast during the

The industrial harbor located on President's Island attracted several major industries to Memphis when it opened in 1955.

March 27 election supported each of the specific bond issues proposed by local government, including $5 million for new school buildings, $3 million for street repairs, $2.11 million for new parks and $2 million each for upgrades to the municipal airport and fairgrounds. In addition, $1,263,000 for hospital construction, $1 million for improved sewers, $525,000 for the industrial harbor, $300,000 for library construction and $200,000 for a new garbage plant were also allocated by the bond issue.

The money allocated by the 1947 referendum did modernize much of the city's infrastructure, but it was hardly an ambitious plan. More money was certainly needed for airport and sewer improvements, as well as school and library construction. The inability to fully fund infrastructure improvements hobbled Memphis as it tried to compete with other southern urban centers. For example, in 1946 Atlanta had passed a $40.4 million bond issue that included more money for airport, school and library construction than Memphis would allocate one year later. These additional funds certainly played a role in Georgia's capital becoming the preeminent southern city in

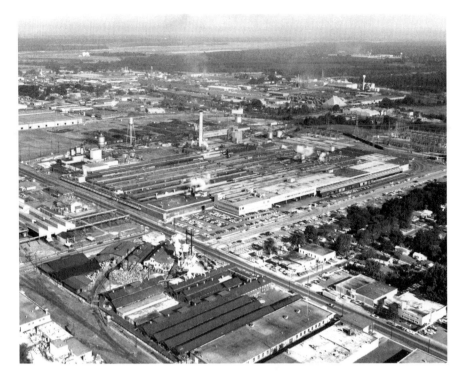

Built in 1936, the Firestone Tire and Rubber Company's Memphis plant remained an important source of jobs until it closed in 1983.

the second half of the twentieth century.[40] Nevertheless, the local economy was reasonably sound, and the city's industrial harbor made Memphis an important distribution point for goods shipped by rail and river to destinations across the United States.

Despite the many changes brought about by the Second World War, Edward Hull Crump, whom *Time* magazine described as "the most absolute political boss" in the country, remained firmly in control of the Bluff City. Crump's machine was so efficient because it was a broad-based coalition made up of nearly every major voting bloc in the city, including African Americans and Republicans. Both minorities participated in the electoral process, but neither could field their own candidates nor were they members of the organization's inner circle. Forced to sit on the sidelines, both groups seethed as Crump's Democratic organization controlled the machinery of government. However, later that year, Crump made two fundamental mistakes that weakened his machine and left slightly ajar the door of political power that had so long been closed to African Americans and Republicans.

Crump's first mistake was to support for the United States Senate a poor campaigner whom he'd never met. Cookeville circuit judge John Mitchell had served in both world wars, and Crump believed that the veterans vote would be very important, so he endorsed Mitchell rather than incumbent Tom Stewart or Chattanooga congressman Estes Kefauver. Several prominent white Memphians—including attorney Lucius Burch, businessman Edmund Orgill and *Memphis Press-Scimitar* editor Edward Meeman—openly supported Kefauver, as did many African Americans. With the vote split three ways, the ballots cast by white liberals and African Americans played a crucial role in electing Kefauver to the Senate and, consequently, weakening Crump's influence on statewide affairs.

The Memphis leader's second error was in opposing President Harry Truman's moderate civil rights program and supporting Strom Thurmond's Dixiecrats in the 1948 presidential campaign. Because of Crump's efforts, the Dixiecrats won a bare majority of votes in Shelby County, but more than twenty-three thousand ballots were cast for Truman, who did not even

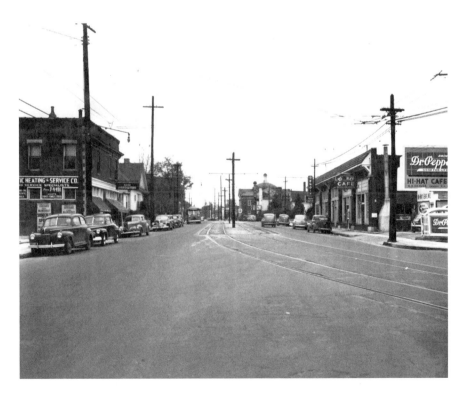

Cooper Street near Union Avenue in midtown Memphis during the 1950s.

campaign in the Bluff City. As in the Democratic primary, it was African Americans and white liberals who voted heavily for the president and again handed the county organization an electoral defeat. Crump's power in Memphis remained largely intact until his death in 1954, but the elections of 1948 set in motion events that eradicated Jim Crow segregation and the outmoded commission form of government and established a two-party system in the Bluff City.

As Crump brooded over his loss, black leaders devised a three-prong strategy to rectify inequality in Memphis. The first of these was to increase black political participation in order to elect African Americans to political office. At the same time, individual African Americans, supported by the local branch of the NAACP, filed lawsuits against the city's segregated public facilities. The third strategy, nonviolent protest, was implemented in the early 1960s by college students impatient with the political and legal tactics and heavily influenced by the sit-ins in North Carolina and the work of Dr. Martin Luther King Jr.

The political strategy was first launched in 1951 when Dr. J.E. Walker, founder of Universal Life Insurance Company, ran unsuccessfully for a seat on the local school board. Walker's candidacy was the first of several attempts by African Americans to elect black candidates to public office throughout the 1950s and 1960s. The most far-reaching of these electoral efforts took place in 1959, when several African Americans, most notably attorneys Russell Sugarmon and Benjamin L. Hooks, ran for city offices. Calling themselves the Volunteer Ticket, the black candidates for public works commissioner, juvenile court judge and the school board campaigned as a group and appeared together at several large rallies. At one well-attended rally, the visiting Dr. Martin Luther King Jr. urged voters to support the ticket "because this election will give impetus for our whole civil rights struggle to every Negro in the United States." Like Walker's 1951 candidacy, the Volunteer Ticket was defeated at the polls, but it nevertheless was very important. The enthusiasm and organizational skill that emerged during the 1959 campaign effectively integrated the Bluff City into the broad civil rights movement then sweeping across the southern United States. As black newspaper columnist Nat D. Williams put it, "At last Memphis was in the 'cause'…and the headlines." Not long after the election, the leadership of the Volunteer Ticket formed the Shelby County Democratic Club to continue working toward the goal of electing African Americans to public office.

African American political strength grew during the early years of the next decade, and in 1964 voters successfully elected black attorneys A.W. Willis and H.T. Lockard to the Tennessee House of Representatives and

the Shelby County Quarterly Court, respectively. Two years later, in 1966, Russell Sugarmon was elected to the Tennessee General Assembly, and in 1967, three African Americans—Fred Davis, James L. Netters and J.O. Patterson Jr.—were elected to the Memphis City Council. The election of African Americans to public office in the 1960s completed the political revolution that began with the strategy of bloc voting first employed in 1911.

The political wing of the Memphis civil rights movement was closely tied to the lawsuits that attempted to topple the legal structure that upheld segregation in the Bluff City. In 1956, black postal worker O.Z. Evers filed suit against the Memphis Street Railway after he was forced out of the whites-only section of a bus. Represented by local NAACP president H.T. Lockard and famed civil rights attorney Thurgood Marshall, Evers argued that Tennessee's segregated streetcar law was unconstitutional. However, a panel of three federal judges ignored a similar U.S. Supreme Court ruling that Alabama's segregated bus-seating law was unconstitutional and instead ruled that Evers had not been injured by the law and had filed suit only to challenge the existing statute. However, fearing further lawsuits, the street railway company formally ended segregated seating in September 1960. A second anti-segregation lawsuit was filed in 1958 by World War II veteran and bank cashier Jesse Turner when he was denied access to the main branch of the Memphis Public Library. The case slowly wound its way through federal court, but by early 1960, the case still had not been heard.

With little progress being made by either political participation or lawsuits, a group of local college students decided to employ nonviolent protest to weaken the grip of segregation. Heavily influenced by the teachings of Dr. Martin Luther King Jr. and the actions of sit-in demonstrators in Greensboro, North Carolina, students from LeMoyne College and Owen Junior College staged a series of protests at public libraries, downtown lunch counters and Overton Park. At first, local government attempted to prosecute the demonstrators, but when they continued in spite of white opposition, Mayor Henry Loeb and the city commission agreed to desegregate libraries, schools and downtown lunch counters. However, the city's parks remained rigidly segregated. The Memphis Park Commission adopted a gradual desegregation plan that would take ten years to fully integrate the city's public recreational facilities. A lawsuit was filed that made its way to the U.S. Supreme Court, and in a unanimous decision handed down in May 1963, the court declared that Memphis's desegregation plan was "patently unconstitutional racial discrimination." The court also stated that "*Brown* never contemplated that the concept of 'deliberate speed' would

countenance indefinite delay in elimination of racial barriers in schools, let alone other public facilities not involving the same physical problems or comparable conditions." When the *Watson* decision was handed down in May 1963, legalized segregation ceased to exist in Memphis.

While African Americans were working to destroy segregation, local Republicans were seeking to break the Democratic Party's firm grip on the political life of Memphis. The growth of the Republican Party as a viable alternative for Memphis voters began in 1952 when African American and former Memphian Robert Church Jr. endorsed General Dwight Eisenhower for the GOP presidential nomination. When he unexpectedly died during the campaign, Church's daughter was elected in his stead to the Tennessee State Executive Committee as a staunch Eisenhower supporter. At the Republican National Convention, Memphis black leader George W. Lee seconded the nomination of Ohio senator Robert A. Taft, but when Eisenhower won the GOP's presidential nod, Lee campaigned vigorously for the retired general.

At the same time, a group of white Memphians formed the Citizens for Eisenhower-Nixon Club because the GOP nominee was "the only man who can rid us of the evils of the Democratic Party." Recognizing that they were making inroads in the solid Democratic South, Eisenhower in October 1952 visited the Bluff City, where he conferred with George W.

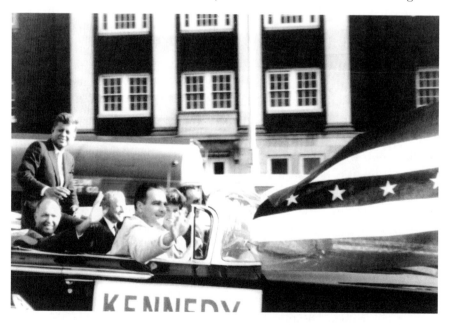

Democratic nominee John F. Kennedy campaigned in Memphis on September 21, 1960.

Lee outside his Beale Street office. Eisenhower did not win a majority of votes in Shelby County, but he did win the 1952 presidential election, and this victory positioned the GOP as a viable competitor to the Democrats for the first time since Reconstruction. Four years later, Eisenhower became the first Republican presidential nominee to win a majority of votes in Shelby County.

Since the 1920s, Lee and moderate white Republicans had worked to carve out a place for African Americans within the GOP fold, and their efforts on behalf of Eisenhower had laid the foundation for two-party politics in the Bluff City and made Memphis a small but key battleground in the 1960 presidential contest. For the first time in its history, Memphis was visited by both major party candidates, John F. Kennedy and Richard Nixon. The GOP nominee courted black Memphians more aggressively than Kennedy did, which resulted in him winning Shelby County by a slim 916 votes. Despite the fact that the black vote supported Nixon in 1960, there were some white Republicans who wanted to purge blacks from the GOP and thus create a segregated two-party system in Memphis.

In 1962, these white conservatives formed the Republican Association expressly to remove Lee from the State Executive Committee. Despite his long service to the GOP, Lee lost his reelection bid, and two years later he was barred from attending the 1964 Republican National Convention as a delegate. The purge of Lee led to a conservative takeover of the Shelby County Republican Party and played a part in nominating Arizona senator Barry Goldwater for president in 1964. As in the 1960 campaign, the Republican and Democratic nominees visited the Bluff City. President Lyndon Johnson, despite the growing strength of the conservative wing of the GOP, won a majority of votes in Shelby County, and liberal democrat George Grider was elected to the ninth district Congressional seat. The fortunes of the Shelby County Democratic Party quickly deteriorated, however, a mere two years later when Memphians abandoned Grider and elected staunch conservative Dan Kuykendall to congress in 1966. A year later, two Republicans, Robert James and Lewis Donelson, were elected to the newly formed Memphis City Council. As a result of these GOP successes, a viable two-party political system had been built in Memphis by the end of the 1960s.

While African Americans and Republicans were revolutionizing local politics, a similar effort was launched to reform the Bluff City's governmental structure. In 1949, attorney Lucius Burch and business leader Edmund Orgill founded the Civic Research Committee to promote nonpartisan citizen involvement in local affairs. Throughout the early 1950s, the Civic

Research Committee argued that Memphis needed to replace the mayor and commission with a city manager hired by a part-time city council. The committee held public forums and debates to further its cause, but most Memphians were satisfied with the political status quo. However, the city manager campaign was an important factor in Memphis adopting the mayor/city council form of government in 1967. In addition, petty squabbling during the tenures of Mayors Edmund Orgill, Henry Loeb and William Ingram convinced some that the city commission was woefully unequipped to govern a municipality the size of Memphis. Consequently a group of local reformers organized several mass meetings in early 1966 to discuss amending the city's charter. Out of these meetings came the organization Program for Progress, which, with citizen input, crafted a form of government that divided executive and legislative authority between a full-time mayor and part-time city council. Voters approved the measure later that year, and the newly adopted mayor/council form of government took effect in January 1968.[41]

Although legalized segregation was defeated in Memphis in 1963, the struggle for equality continued. In 1968, mass demonstrations in support of striking sanitation workers forced Mayor Loeb to recognize city employees' rights to organize a union after Martin Luther King Jr. was assassinated on April 4. The following year, a citywide school boycott, and several massive protest marches were organized that led to the hiring of more African American teachers and black representation on the school board. In April 1972, federal judge Robert M. McRae Jr. ordered that thirteen thousand schoolchildren be transferred to ensure full desegregation of Memphis city schools. The court-ordered busing plan was implemented on January 24, 1973, with no violence and little protest despite the opposition of many Memphians. By the early 1970s, the three-pronged strategy that black Memphians had crafted to topple legalized discrimination had succeeded in electing African Americans to high public office and desegregating the Bluff City's public spaces.

This is not to say that Memphis became a racial utopia overnight. In fact, the troubled legacy of discrimination continued to define how the city operated for the rest of the twentieth century. Mutual animosity and suspicion between black and white Memphians, which had existed when the city was founded in 1826, reached its zenith in the years following the murder of Dr. King. At the same time, the national media vilified the city, describing it in the late 1960s and 1970s as a "decaying Mississippi River town," "a city that wants never to change" and "the Sun Belt's dark spot." In addition

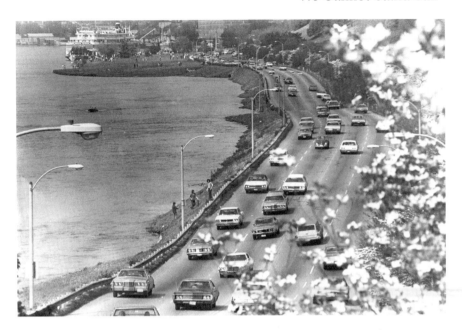

In the 1970s, Riverside Drive kept Memphians connected to its historic downtown core despite the closing of such venerable Memphis institutions as Beale Street and the Peabody Hotel.

to contributing to a kind of collective inferiority complex, this image also severely hampered the city's economic development. When the recession of the 1970s and early 1980s led to the closing of such major industries as Firestone and International Harvester, Memphis leaders were unable to lure new businesses because of its reputation as a provincial city mired in racial turmoil. As industries fled, the downtown core deteriorated to such a degree that such famous landmarks as Beale Street and the Peabody Hotel were abandoned by Memphians who only a few years before had taken great pride in these historic institutions.

Downtown buildings and Memphis's reputation were not the only things that deteriorated in the 1970s. Low wages had been a hallmark of the local economy for decades, but as the recession deepened, the cost of living rose to a point that many Memphis workers saw their take-home pay dwindle. Especially hard hit were employees of the fire and police departments. During the summer of 1978, Mayor Wyeth Chandler offered both firefighters and police officers a 17 percent pay raise spread over two years, but the fire union rejected the proposal. On July 1, 1978, eight hundred firefighters walked off the job, just as their predecessors had done in 1920. Mayor Chandler reacted much the same as Rowlett Paine did: striking firefighters were threatened

with dismissal, while the Tennessee National Guard manned key fire stations in the city. There was one important difference, however, between 1920 and 1978. Unlike sixty-eight years before, uncontrolled fires spread across Memphis, damaging homes, vacant buildings and even a public library. Many of them were undoubtedly set by striking firefighters, who in many instances stood by and calmly watched the city burn. On July 3, Chancery Court judge Robert Hoffman signed a temporary writ of injunction prohibiting the fire union from engaging in a strike and ordering all firefighters to return to work the following day. The strike was over, but the resentment that many public employees felt toward city government continued to fester.

On the evening of July 4, the day the firefighters went back to work, members of the Memphis Police Association voted to reject the city's 17 percent wage increase. The next day, negotiations resumed between the city and the fire and police unions, but no settlement was reached after a month of tense proceedings. On August 10, frustrated police officers walked off the job but, like the fire union, were ordered by chancery court to return to work or be terminated. When striking officers refused, Mayor Chandler began removing striking police from city payroll. Furious at both the court and the mayor, strikers threw rocks and smashed the windows of government buildings, while others opened fire on city hall. Four days later, on August 14, firefighters joined their police comrades on the picket line, leaving Memphians vulnerable to both criminal activity and conflagrations. A curfew was imposed by Mayor Chandler, and Memphians watched from their windows as national guardsmen patrolled the darkened city streets.

Most Memphians were exasperated with the behavior of both the mayor and the unions as the strike dragged on. An editorial published in the *Press-Scimitar* newspaper declared: "It is a terrible thing that Memphis—the 'place of good abode'—has come to this: Citizens feeling threatened by those whom their tax dollars pay to protect them [and a] hard-nosed city administration that apparently confuses negotiation with confrontation." Then things grew worse. At 12:33 a.m. on August 16, a drunken security guard at a Light, Gas and Water substation sabotaged the equipment, plunging the city into total darkness. Pandemonium soon erupted in several blackened neighborhoods; burglaries and robberies were reported across the city, a security guard fatally shot a looter and the National Guard nervously surrounded city hall, the county jail and police headquarters.

As might be expected, the national media had a field day with Memphis's travails. The *Today* show and ABC's *Good Morning America* both did lengthy stories on the strike, and comedienne Jane Curtin arrived in the city to

Mayor Wyeth Chandler bitterly opposed striking firefighters and police officers during the summer of 1978.

film a sketch entitled "How I Spent my Vacation in Memphis" for the NBC network television series *Saturday Night Live*. The most scathing report appeared in a column published in the *Atlanta Journal-Constitution*, which declared that Memphis "has not lived for years. That anarchy reigns now, that knaves and fools run wild in the streets unfettered by constraints of

order and sanity, is a disconsolate epitaph to the decline of a civilized city." The blackout, combined with public pressure and unflattering national media coverage, finally forced all sides to settle the strike on August 18. Although many Memphians blamed Mayor Chandler, most of their bitterness was directed toward the fire and police. Voters overwhelmingly supported a charter change that required that all striking city employees be dismissed and, if rehired, would lose all seniority, while Mayor Chandler was easily reelected in 1979.[42]

Despite these serious problems, the local economy did not suffer quite as much as it had in the 1870s. The industrial harbor continued to bring much-needed business to the city, and St. Jude's Children's Research Hospital, opened in 1962 by entertainer Danny Thomas, successfully positioned the city as a major medical center. Economic conditions were also improved when Kemmons Wilson founded his Holiday Inn motel chain in 1952. Like Clarence Saunders's Piggly Wiggly grocery stores, Holiday Inn also revolutionized an American industry. Wilson's motels did much more than provide a roof over travelers' heads. Holiday Inns offered their guests such luxuries as ice machines, swimming pools and TV sets, as well as telephones in each room. These innovations profoundly changed Americans' expectations of what motel service should provide. By the early 1970s, Holiday Inns operated 1,350 motels around the world and had an annual profit of $600 million.

Memphis's reputation as an important distribution center was greatly enhanced in 1972 when entrepreneur Fred Smith founded the air cargo company FedEx, which transformed mail service in the United States by offering overnight package delivery to consumers. By century's end FedEx employed thirty thousand Memphians and was one of the nation's most important global companies. Another significant economic asset for the city was its internationally recognized musical heritage.

What became known as the Memphis sound was first heard in 1907 when African American bandleader William Christopher Handy relocated to the Bluff City. In Memphis, Handy composed songs based on blues music he had heard while performing in the Mississippi Delta. Many of his songs, including "Memphis Blues" and "Beale Street Blues," brought national recognition to both the African American composer and his adopted hometown. As a result of Handy's exposure, along with its status as the unofficial capital of the Mid-South and the Mississippi Delta, Memphis became an important performance and recording destination for blues musicians from across the region. The music created in and around Memphis attracted many to the Bluff City, including a radio engineer from Alabama named Sam Phillips.

William Christopher Handy (seen here with his wife, Louise) composed blues songs, such as the "Beale Street Blues," and laid the foundation for the Memphis sound.

Wanting to provide an outlet for "Negro artists in the South who wanted to make a record and just had no place to go," Phillips opened the Memphis Recording Service at 706 Union Avenue in 1950. Phillips had a kind of mystical belief in the power of music to overcome the South's poverty and racism. As he later explained:

I think one thing we did…was help change attitudes a bit. We didn't go out and try to consciously tell people that they were wrong about what they thought; we just went out and recorded the music of black people and poor white people. We sought out underprivileged people that had talent, and we went into the studio and let them tell their story.

Elvis Presley, the King of rock-and-roll, profoundly influenced the development of the Memphis sound and forever changed American popular music.

Charging only a small fee, Phillips's company brought many performers to Union Avenue, including Jackie Brenston and Ike Turner, who recorded "Rocket 88" there in 1951. When the single was released by Chess records and became a popular hit, Phillips formed Sun Records, where he recorded Rufus Thomas, B.B. King, Little Junior Parker, Roscoe Gordon and many other rhythm and blues artists.

Then, in the summer of 1953, a white eighteen-year-old machine shop employee named Elvis Presley walked into 706 Union Avenue to record a song in hopes of being noticed. After nearly a year of finding excuses to drop by the studio, he was finally asked by Phillips to professionally record a number. Intrigued by Presley's voice, Phillips experimented with the young man's vocal range and later paired him with guitarist Scotty Moore and bassist Bill Black. After several false starts, the trio, under Phillips's watchful eye, fused different musical styles into a rollicking new sound made up of equal parts country, rhythm and blues, jazz and popular ballads. When Elvis, Scotty and Bill's version of Arthur "Big Boy" Crudup's song "That's Alright Mama" was played on Dewey Phillips's (no relation to Sam) *Red, Hot and Blue* program on WHBQ radio, it launched a revolution in American popular music that soon spread as the boys performed across the South. The popularity of Presley's records and live performances caught the attention of RCA Records, which bought his contract from Phillips for the then unheard-of sum of $35,000. With Elvis gone from Sun, Phillips turned his attention to other talented white artists, such as Johnny Cash, Jerry Lee Lewis and Carl Perkins, which solidified Memphis's position as the birthplace of rock-and-roll music and Phillips's reputation as an American visionary.

Although Sun's catalogue contained both African American and white artists, the music was recorded separately and marketed to different audiences. Soul music, at least partly born in Memphis, was created differently than segregated rock-and-roll. Soul, according to music historian Peter Guralnick, "is the story of blacks and whites together. It is the story of the complicated intertwinings of dirt-poor roots and middle-class dreams, aesthetic ambitions and social strivings." In 1958, bank employee and part-time musician Jim Stewart formed Satellite Records and began releasing country records. Later that year, his sister Estelle Axton joined the nascent company, and in 1960, they opened a studio and record shop in South Memphis at the intersection of College and McLemore. Satellite's first star was Carla Thomas, Rufus's daughter, who took the song "Gee Whiz" to number ten on the 1961 Billboard chart. This was soon followed by the Mar-

Founded by Jim Stewart and Estelle Axton, Stax Records produced soul music that played an important role in the city's musical revolution.

Keys, whose single "Last Night" also became a national hit. As they were enjoying their newfound success, Stewart and Axton discovered that there was another record label called Satellite. Taking the first two letters from each of their last names, they rechristened their company Stax.

The roster of talent at Stax was just as long and celebrated as at Sun's: the Bar-Kays, Booker T. and the MGs, Eddie Floyd, Wilson Pickett, Otis Redding, Sam and Dave, the Staple Singers and Rufus Thomas all recorded in South Memphis, and the prolific songwriting team of David Porter and Isaac Hayes created many of the company's signature hits. Hayes was perhaps Stax's most successful artist; his album *Hot Buttered Soul* sold 3 million copies, and he won an Academy Award for his theme to the movie *Shaft*. Stax not only produced great soul music, but more importantly, at a time when this was exceedingly rare, it was also the only truly integrated business in the city of Memphis. African Americans and whites worked side by side in the recording studio and shared management responsibilities. In this way,

Isaac Hayes's album *Hot Buttered Soul* sold 3 million copies for Stax Records.

Stax represented the best of Memphis culture and played an important role in the city's musical revolution.

By the end of the twentieth century, Memphis's significant contributions to American popular music had not gone entirely unnoticed. For example, a representative of the Smithsonian Institution's National Portrait Gallery once remarked that "Memphis, Tennessee is to music as

Nineteenth Century Paris is to art," and the author of *Cities in Civilization*, Sir Peter Hall, declared that "[w]hat the Memphis story finally shows is that the music of an underclass could literally become the music of the world." The world poured into Memphis to mourn the loss of Elvis Presley when he died unexpectedly in his Graceland home on August 16, 1977. A year later they returned, spawning a tourism industry that would bring millions of dollars into the Bluff City each year. Tourism grew further when Elvis's home, Graceland, the Beale Street entertainment district and the National Civil Rights Museum were opened to the public in the 1980s and early 1990s.

In October 1991, Memphians elected Willie Herenton their first African American mayor, and his election coincided with a resurgence of interest in the culture and people of the Bluff City. As Memphians prepared for the mayoral campaign, the song "Walking in Memphis" by Marc Cohn was making its way up the Billboard top one hundred singles chart. Eventually becoming a top ten hit, the song was inspired by a visit

When Elvis Presley (seen here practicing karate with his instructor, Kang Rhee) died in 1977, the outpouring of grief launched Memphis's lucrative tourism industry.

to Memphis, where the composer visited Beale Street, Graceland and the church of Grammy Award–winning singer Al Green. During his stay, Cohn discovered that in spite of his being a native Ohioan, Memphis "somehow feels like home."

A year after "Walking in Memphis" became a hit single, a Hollywood production company arrived in the Bluff City to film an adaptation of John Grisham's bestselling novel *The Firm*. Set in the Bluff City, the novel featured a young lawyer who joins a local firm only to discover that it is controlled by a national crime syndicate. In November 1992, a film crew from Paramount pictures began filming in Memphis, much to the delight of many residents, who closely followed the movements of Hollywood stars Tom Cruise, Gene Hackman and Jeanne Tripplehorn. Academy Award–winning director Sydney Pollack filmed scenes throughout the city, including at the Peabody Hotel, on Beale Street, at the Cotton Exchange and at the abandoned International Harvester plant. In addition to the locations, many Memphians secured work as extras, which added to the authenticity of the production. When *The Firm* was released in June 1993, many Memphians were relieved to learn of its critical and box office success. To the surprise of industry leaders, it took only twenty-two days for the film to gross $101.2 million. "Nothing in this genre—an adult melodrama thriller—has ever done these numbers. Historically, only action-adventure, high-tech movies achieve these kinds of results," declared Paramount president Barry London.

"Walking in Memphis" and *The Firm* reintroduced the Bluff City to millions of Americans who, if they thought about it at all, only remembered that it was the place where Martin Luther King Jr. and Elvis Presley died. The song and movie were but two examples of filmmakers, journalists and scholars reexamining Memphis and its people during the final decade of the twentieth century. For another example, a writer for *U.S. News and World Report* declared that "Memphis manages to preserve the diversity and pure Southern quirkiness that made it the logical birthplace of rock-and-roll." This theme was echoed by *American Heritage*, whose editors urged Americans to visit the Bluff City because "the sultry mysterious Memphis…will cast its luxuriant, disturbing spell."

Initially described as nothing more than "a group of rather miserable houses," Memphis in its first two centuries of existence overcame the legacy of organized crime, disease, municipal bankruptcy, war, racism and a sense of inferiority to become one of America's great cities. The fact that Memphians achieved this while remaining true to the better aspects of their culture was noticed by shrewd observers, such as director Sydney Pollack.

Reflecting on his brief time in the Bluff City, Pollack declared, "I never in my life felt so welcome. People knocked themselves out for you. I'll tell you one thing. It turns out that this Southern hospitality crap isn't crap, or at least it isn't in Memphis."[43]

NOTES

CHAPTER 1

1. Roper, *Founding of Memphis*, 38–39, 47–51; Long, "Memphis Mayors 1827 to 1866," 105–130; *Memphis Commercial Appeal,* June 29, 1930.
2. Roper, "Isaac Rawlings, Frontier Merchant," 265–66; Keating, *History of the City of Memphis*, 139–40; Capers, *Biography of a River Town*, 36.
3. Vedder, *History of the City of Memphis*, 15; Walk, *Memphis Executive and Legislative Government*, 3, 9.
4. Municipal Reference Library, *Summary of Minutes of City Council*, 1; Long, "Memphis Mayors 1827 to 1866," 107; Keating, *History of the City of Memphis*, 183.
5. Long, "Memphis Mayors 1827 to 1866," 108; Roper, "Isaac Rawlings, Frontier Merchant," 277.
6. Municipal Reference Library, *Summary of Minutes of City Council*, 8, 14; Long, "Memphis Mayors 1827 to 1866," 111.
7. Capers, *Biography of a River Town*, 49–50, 73; Keating, *History of the City of Memphis*, 228.
8. Davis, *History of the City of Memphis*, 98–103.
9. Municipal Reference Library, *Summary of Minutes of City Council*, 90–91; Mehrling, "Memphis and Charleston Railroad," 22–23; Bejach, "Seven Cities Absorbed by Memphis," 96–97; Magness, *Past Times*, 215–18; Capers, *Biography of a River Town*, 96–101.

CHAPTER 2

10. Sigafoos, *Cotton Row to Beale Street*, 32–33; Capers, *Biography of a River Town*, 138, 149; Municipal Reference Library, *Summary of Minutes of City Council*, 92, 190; City of Memphis, Minutes of the Board of Mayor and Aldermen, August 7, 1860.

11. Cupples, "Memphis Confederates," 39–46; *Memphis Daily Avalanche*, July 3, 1861; Egerton, *Year of Meteors*, 51–55, 134–35; Schlesinger, Israel and Hansen, *History of American Presidential Elections*, 1,124–27; *Memphis Daily Appeal*, "Great Gathering of the Democratic Masses at Memphis!"; Capers, *Biography of a River Town*, 137.

12. *Memphis Daily Appeal*, "Great Gathering of the Masses!"; Capers, *Biography of a River Town*, 140, 143–49; Whiteaker, "Civil War," 168–71; Cupples, "Memphis Confederates," 66–67; Bergeron, Ash and Keith, *Tennesseans and Their History*, 136–37; *Memphis Daily Avalanche*, July 3, 1861; Jones, *A List of General and Special Orders*, 3; City of Memphis, Minutes of the Board of Mayor and Aldermen, March 18 and April 1, 1862; Keating, *History of the City of Memphis*, 513–14.

13. City of Memphis, Minutes of the Board of Mayor and Aldermen, July 8 and 10, 1862; Capers, *Biography of a River Town*, 152, 156, 158; Jones, *A List of General and Special Orders*, 8; Grant, *Personal Memoirs of U.S. Grant*, 1,132; City of Memphis, Minutes of the Board of Mayor and Aldermen, July 28, 1862; Bordelon, "Rebels to the Core," 9–10; Sherman, *Memoirs of General W.T. Sherman*, 1,099.

14. Jones, *A List of General and Special Orders*, 33–34, 41, 44; Foner, *Fiery Trial*, 240–42, 294, 313–14, 345; Corlew, *Tennessee*, 328–32.

CHAPTER 3

15. Lovett, "Memphis Riots," 10–12; Rable, *But There Was No Peace*, 35–37; Nazor, *Memphis City Police Station Book*.

16. United States Congress, House Select Committee on the Memphis Riots, *Memphis Riots and Massacres*, 23, 37–38, 50, 52, 122; *Public Ledger*, "Riot in South Memphis," May 2, 1866; *New York Times*, "Riot in Memphis," May 12, 1866; Rable, *But There Was No Peace*, 38–39.

17. *Memphis Daily Avalanche*, October 12, 13 and 15, 1866; Capers, *Biography of a River Town*, 180–81; Keating, *History of the City of Memphis*, 578–79.

18. Lamon, *Blacks in Tennessee*, 35–36; Capers, *Biography of a River Town*, 173; *Memphis Daily Appeal,* January 1, 1868; *Memphis Public Ledger*, "The Result," January 3, 1868.

19. City of Memphis, Minutes of the Board of Mayor and Aldermen, April 7 and May 5, 1868; Keating, *History of the City of Memphis*, 588–89, 609; Walk, *Memphis Executive and Legislative Government*, 4–5; Capers, *Biography of a River Town*, 182; *Daily Memphis Avalanche,* January 3, 4, 5, 8 and 12, 1873.

20. Capers, *Biography of a River Town*, 188, 192–93; LaPointe, *From Saddlebags to Science*, 21; City of Memphis, Minutes of the Board of Mayor and Aldermen, September 18, October 4 and November 3, 1873.

21. *Memphis Daily Appeal*, December 21 and 29, 1873, and January 1 and 2, 1874; City of Memphis, Minutes of City Council, Board of Health, Etc., February 12 and May 6, 1874; Wrenn, *Crisis and Commission Government in Memphis*, 25–26.

22. *Digest of the Charter and Ordinances of the City of Memphis, 1876*, 24–25; Wrenn, *Crisis and Commission Government*, 26; *Memphis Daily Appeal,* January 6 and 7, 1876, and January 14 and 18, 1878; Keating, *History of the City of Memphis*, 648–50.

23. *Digest of the Charter and Ordinances of the City of Memphis, 1876*, 24–25; Wrenn, *Crisis and Commission Government*, 26; *Memphis Daily Appeal,* January 6 and 7, 1876, and January 14 and 18, 1878; Keating, *History of the City of Memphis*, 648–50; LaPointe, *From Saddlebags to Science*, 23–25; Wrenn, *Crisis and Commission Government*, 22, 27; Bloom, *Mississippi Valley's Great Yellow Fever Epidemic*, 160–61.

Chapter 4

24. *Daily Memphis Avalanche*, January 3, 14, 15 and 16, 1879; *Memphis Daily Appeal,* January 11, 1879; Wrenn, *Crisis and Commission Government*, 30, 198.

25. Wrenn, *Crisis and Commission Government*, 32, 36–37, 39, 43–44, 66–67; *Memphis Daily Appeal*, February 1 and 7, 1879; Goings and Smith, "Unhidden Transcripts," 382; Ellis, "Memphis' Sanitary Revolution," 64–65; Clemens, *Life on the Mississippi*, 204.

26. Wrenn, *Crisis and Commission Government*, 42–43, 45, 56, 60–61, 124–25, 128–30; Walk, *Memphis Executive and Legislative Government*, 57; *Memphis Daily Appeal*, December 25, 28 and 30, 1881; *Memphis Daily Appeal*, January 6, 1882; *Memphis Daily Appeal,* January 7 and 8, 1890.

27. Webb, "People's Grocery and the Lynching at the Curve," *Tri-State Defender*, February 12, 2005; Wrenn, *Crisis and Commission Government*, 130–33, 140–

51; Caplinger, "Conflict and Community, 50; *Memphis Appeal-Avalanche*, January 2, 3 and 4, 1894; Dowdy, *Hidden History of Memphis*, 65; Coppock, *Paul R. Coppock's Mid-South*, 100–101; Miller, "J.J. Williams and the Greater Memphis Movement," 14–15.

28. Miller, "J.J. Williams and the Greater Memphis Movement," 15–16; *Memphis Commercial Appeal*, October 4, 5 and 9, 1898; Miller, *Memphis During the Progressive Era*, 17, 73, 76, 145.

29. Miller, *Memphis During the Progressive Era*, 81–82, 90–91, 94–95, 131–35.

30. State of Tennessee, *Amendment to Charter of the City of Memphis*, 1, 4–5, 14; Dowdy, *Mayor Crump Don't Like It*, 10; Miller, *Memphis During the Progressive Era*, 135–39, 141–43; *Memphis Commercial Appeal*, July 12, 13 and 22, 1904; *Memphis Commercial Appeal*, November 8 and 10, 1905.

Chapter 5

31. Miller, *Memphis During the Progressive Era*, 74–75, 145–46; Dowdy, *Mayor Crump Don't Like It*, 3–4; Miller, *Mr. Crump of Memphis*, 58–59, 63; *Memphis Commercial Appeal*, January 3, 1908.

32. Dowdy, *Mayor Crump Don't Like It*, 4, 10–11, 13, 18–20; Frye, "For Their Exclusive Enjoyment," 18, 21; Robert Sullivan and J.R. Fields to E.H. Crump, n.d., E.H. Crump Collection, Memphis Public Library and Information Center; Sergeant J.S. Pruett to Police Chief W.J. Hayes, December 19, 1913, Crump Collection; Kitchens, "Ouster of Edward H. Crump," 109.

33. Freeman, *Clarence Saunders and the Founding of Piggly Wiggly*, 29, 59; Miller, *Mr. Crump of Memphis*, 128; Phillips, "Rowlett Paine, Mayor of Memphis,", 96–99; Dowdy, *Mayor Crump Don't Like It*, 27, 30–31.

34. Phillips, "Rowlett Paine, Mayor of Memphis," 102; *Memphis News Scimitar*, July 15, 1920; *Memphis Commercial Appeal*, July 15, 16, 17, 18 and 20, 1920; *Memphis Press-Scimitar*, "City Plan Had Its Beginning 2 Decades Ago"; *Spencer-Sturla Company v. City of Memphis*, 1–3; City Planning Commission and Bartholomew, *A Comprehensive City Plan*, 5, 117–21; Steverson, "Union Avenue"; Huebner, "Respect Church's History."

35. Miller, *Memphis During the Progressive Era*, 96; Dowdy, *Mayor Crump Don't Like It*, 45–52, 80–81.

CHAPTER 6

36. *Memphis Evening Appeal*, "Loan Shark Cleanup Drive Was Started One Year Ago"; *Memphis Commercial Appeal*, "Discovery of Opium Den in City Brings 12 Arrests"; Biles, *Memphis in the Great Depression*, 50–53, 56–57, 63–64, 78–79; Dowdy, *Mayor Crump Don't Like It*, 55, 70–71.

37. Dowdy, *Mayor Crump Don't Like It*, 80–81, 100–7; *Memphis Press-Scimitar*, "Police Clamp That Lid Again."

38. Dowdy, "Sin in Memphis," 171–93; *Time*, June 10, 1940, 22–23; American Social Hygiene Association, *Commercialized Prostitution Conditions*, Crump Collection; Dowdy, "Memphians Will Do Their Duty," 3–4, 8; Dowdy, *Hidden History of Memphis*, 60, 63.

39. E.H. Crump to Clifford Davis, January 25, 1941, Crump Collection; Walter Chandler to E.H. Crump, September 16, 1942, Crump Collection; Walter Chandler to E.H. Crump, September 16, 1942, Crump Collection; statement made by Walter Chandler, n.d., Walter Chandler Papers, Memphis Public Library and Information Center; Dowdy, "Memphians Will Do Their Duty," 10–12.

40. Sigafoos, *Cotton Row to Beale Street*, 213; Maum, "President's Island Enhances Transportation, Industry; Terminal Proving Big Help"; Roberts, "Engine of Commerce"; *Memphis Commercial Appeal*, March 27, 1947; Woodbury, "Bond Issues Win Easily; Martin, *Atlanta and Environs*, 123.

41. Dowdy, *Crusades for Freedom*, vii–viii, 2–21, 28–32; 66–72, 75–84, 90, 98–102, 104–8, 111–18, 122–32.

42. Egerton, *Promise of Progress*, 6–7; Dowdy, *Hidden History of Memphis*, 19; Palmer, "I'm Tired of Feeling Like a Garbage Man," 108–113, 251–57, 266, 270–72, 282–83, 287–96, 314–20, 327–32; Sullivan, "Crucible of '78."

43. Guralnick, *Last Train to Memphis*, 4–7, 60–63, 90–97, 226–27; "Elvis and Isaac: the Memphis Music Legacy." http://face2face.si.edu/my_weblog, National Portrait Gallery (Smithsonian Institution), August 22, 2008; Bond and Sherman, *Memphis in Black and White*, 132; Guralnick, *Sweet Soul Music*, 18; Donahue, "Memphis Plumbed Musician's Heart, Soul"; Nager, "Cohn to Visit Memphis Again"; Aitchison, "'Firm' Crew Cruises in, gets rolling in Memphis"; *Memphis Commercial Appeal*, "'The Firm' Breaks $100 Million"; Dowdy, *Hidden History of Memphis*, 20; Hall, *Cities in Civilization*, 602; La Badie, "Pollack Peels Away Actors' Artifice."

BIBLIOGRAPHY

ARTICLES

Aitchison, Diana. "'Firm' Crew Cruises in, Gets Rolling in Memphis." *Memphis Commercial Appeal*, November 10, 1992.

Bejach, Lois D. "The Seven Cities Absorbed by Memphis." *West Tennessee Historical Society Papers* volume 8 (1954).

Bordelon, John. "'Rebels to the Core': Memphians Under William T. Sherman." *Rhodes Journal of Regional Studies* 2 (2005).

Donahue, Michael. "Memphis Plumbed Musician's Heart, Soul." *Memphis Commercial Appeal*, April 13, 1991.

Dowdy, G. Wayne. "'Memphians Will Do Their Duty': A Tennessee City During World War II." *West Tennessee Historical Society Papers* 60 (2006).

———. "Sin in Memphis: Organized Crime and Machine Politics in a Southern City, 1935–1940." *Crossroads: A Southern Culture Annual*, 2004.

Ellis, John H. "Memphis' Sanitary Revolution, 1880–1890." *Tennessee Historical Quarterly* 23 (March–December 1964).

Frye, William H. "For Their Exclusive Enjoyment: Racial Politics and the Founding of Douglass Park, Memphis, 1910–1913." *West Tennessee Historical Society Papers* 17 (1993).

Goings, Kenneth W., and Gerald L. Smith. "'Unhidden Transcripts': Memphis and African American Agency, 1862–1920." *Journal of Urban History* 21, no. 3 (March 1995).

Huebner, Timothy. "Respect Church's History of Spiritual Work." *Memphis Commercial Appeal*, December 9, 2010.

Kitchens, Allen H. "Ouster of Edward H. Crump, 1915–1916." *West Tennessee Historical Society Papers* 19 (1965).

La Badie, Donald. "Pollack Peels Away Actors' Artifice." *Memphis Commercial Appeal*, June 26, 1993.

Leigh, Andrew. "Every Third Day Is a Holiday." *Business Observer*, November 14, 1971.

Long, John Mark. "Memphis Mayors 1827 to 1866: A Collective Study." *West Tennessee Historical Society Papers* 52 (1998).

Lovett, Bobby L. "Memphis Riots: White Reaction to Blacks in Memphis, May 1865–July 1866." *Tennessee Historical Quarterly* (Spring 1979).

Maum, Emmett. "President's Island Enhances Transportation, Industry; Terminal Proving Big Help." *Memphis Commercial Appeal*, October 7, 1956.

Mehrling, John C. "The Memphis and Charleston Railroad." *West Tennessee Historical Society Papers* 19 (1965).

Memphis Commercial Appeal. "Discovery of Opium Den in City Brings 12 Arrests." November 23, 1931.

———. "'The Firm' Breaks $100 Million Blockbuster Mark in 22 Days." July 24, 1993.

———. "Stax 'N' Soul: 50 Years of Memphis Music and Magic." June 15, 2007.

Memphis Daily Appeal. "Great Gathering of the Democratic Masses at Memphis! Speech of Mr. Douglas!" October 25, 1860.

———. "Great Gathering of the Masses—Secession in the Ascendant!" January 31, 1861.

Memphis Evening Appeal. "Loan Shark Cleanup Drive Was Started One Year Ago." October 8, 1931.

Memphis Press-Scimitar. "City Plan had Its Beginning 2 Decades Ago." April 19, 1940.

———. "Police Clamp That Lid Again." June 17, 1935.

Memphis Public Ledger. "The Result." January 3, 1868.

———. "Riot in South Memphis." May 2, 1866.

Miller, William D. "J.J. Williams and the Greater Memphis Movement." *West Tennessee Historical Society Papers* (1951).

Nager, Larry. "Cohn to Visit Memphis Again." *Memphis Commercial Appeal,* December 6, 1991.

New York Times. "The Riot in Memphis." May 12, 1866.

Phillips, Virginia. "Rowlett Paine, Mayor of Memphis, 1920–1924." *West Tennessee Historical Society Papers* 13 (1959).

Roberts, Jane. "Engine of Commerce: Terminal Has Towed Business Along for 50 Years." *Memphis Commercial Appeal,* December 7, 2005.

Roper, James. "Isaac Rawlings, Frontier Merchant." *Tennessee Historical Quarterly* 20 (September 1961).

Steverson, William. "Union Avenue: Silk-Stocking Street to Strip City? The Changes Have Been Slow but Sure." *Memphis Commercial Appeal,* June 18, 1978.

Sullivan, Bartholomew. "Crucible of '78—Police, Fire Strike Left Mark on City." *Memphis Commercial Appeal*, August 10, 2003.

Webb, Arthur L. "The People's Grocery and the Lynching at the Curve." *Tri-State Defender*, February 12, 2005.

Whiteaker, Larry H. "Civil War." *Tennessee Encyclopedia of History and Culture*. Nashville: Tennessee Historical Society and Rutledge Hill Press, 1998.

Woodbury, Harry. "Bond Issues Win Easily, Backed by 93 Per Cent of City-County Voters." *Memphis Commercial Appeal*, March 28, 1947.

BOOKS

Bergeron, Paul H., Stephen V. Ash and Jeanette Keith. *Tennesseans and Their History*. Knoxville: University of Tennessee Press, 1999.

Bloom, Khaled J. *The Mississippi Valley's Great Yellow Fever Epidemic of 1878*. Baton Rouge: Louisiana State University Press, 1993.

Bond, Beverly G., and Janann Sherman. *Memphis in Black and White*. Charleston, SC: Arcadia, 2003.

Bowman, Rob. *Soulsville U.S.A.: The Story of Stax Records*. New York: Schirmer Trade Books, 1997.

Capers, Gerald M., Jr. *The Biography of a River Town: Memphis, Its Heroic Age*. New Orleans, LA: Tulane University Press, 1966.

Clemens, Samuel L. *Life on the Mississippi*. New York: Dodd, Mead & Company, 1968.

Coppock, Paul R. *Paul R. Coppock's Mid-South*. Vol. 2, *1971–1975*. Memphis, TN: Paul R. Coppock Publication Trust, 1992.

Corlew, Robert E. *Tennessee: A Short History*. Knoxville: University of Tennessee Press, 1981.

Davis, James D. *The History of the City of Memphis, Also, the Old Times Papers.* Facsimile of the Hite, Crumpton & Kelly 1873 edition, West Tennessee Historical Society, 1972.

Dowdy, G. Wayne. *Crusades for Freedom: Memphis and the Political Transformation of the American South.* Jackson: University Press of Mississippi, 2010.

————. *Hidden History of Memphis.* Charleston, SC: The History Press, 2010.

————. *Mayor Crump Don't Like It: Machine Politics in Memphis.* Jackson: University Press of Mississippi, 2006.

Egerton, Douglas R. *Year of Meteors: Stephen Douglas, Abraham Lincoln, and the Election That Brought on the Civil War.* New York: Bloomsbury Press, 2010.

Foner, Eric. *The Fiery Trial: Abraham Lincoln and American Slavery.* New York: W.W. Norton & Company, 2010.

Freeman, Mike. *Clarence Saunders and the Founding of Piggly Wiggly: The Rise and Fall of a Memphis Maverick.* Charleston, SC: The History Press, 2011.

Grant, U.S. *Personal Memoirs of U.S. Grant and Selected Letters, 1839–1865.* New York: Library of America, 1990.

Guralnick, Peter. *Last Train to Memphis: The Rise of Elvis Presley.* New York: Little, Brown and Company, 1994.

————. *Sweet Soul Music: Rhythm and Blues and the Southern Dream of Freedom.* Boston: Little, Brown and Company, 1986.

Hall, Peter. *Cities in Civilization.* New York: Pantheon Books, 1998.

Jones, James B., Jr., ed. *A List of General and Special Orders Issued by Confederate and Federal Authorities Relative to Memphis and West Tennessee, 1861–1865.* Nashville, Tennessee, 1999.

Keating, J.M. *History of the City of Memphis and Shelby County.* Vol. 1. Syracuse, NY: D. Mason and Company, 1888.

Lamon, Lester C. *Blacks in Tennessee, 1791–1970.* Knoxville: University of Tennessee Press, 1981.

LaPointe, Patricia. *From Saddlebags to Science: A Century of Health Care in Memphis, 1830–1930.* Memphis, TN: Health Sciences Museum Foundation, 1984.

Magness, Perre. *Past Times: Stories of Early Memphis.* Memphis, TN: Parkway Press, 1994.

Martin, Harold H. *Atlanta and Environs: A Chronicle of Its People and Events.* Vol. 3. Atlanta, GA: Atlanta Historical Society, 1987.

Miller, William D. *Memphis During the Progressive Era, 1900–1917.* Memphis, TN: Memphis State University Press, 1957.

———. *Mr. Crump of Memphis.* Baton Rouge: Louisiana State University Press, 1964.

Nazor, Mary Louise. *Memphis City Police Station Book, October 1, 1858 to December 30, 1860.* Memphis, TN: Memphis/Shelby County Archives, 1997.

Rable, George C. *But There Was No Peace: The Role of Violence in the Politics of Reconstruction.* Athens: University of Georgia Press, 1984.

Roper, James. *The Founding of Memphis, 1818–1820.* Memphis, TN: Memphis Sesquicentennial, Inc., 1970.

Schlesinger, Arthur M., Jr., Fred L. Israel and William P. Hansen, eds. *History of American Presidential Elections, 1789–1968.* Vol. 2. New York: Chelsea House Publishers, 1971.

Sherman, William T. *Memoirs of General W.T. Sherman.* New York: Library of America, 1990.

Sigafoos, Robert. *Cotton Row to Beale Street: A Business History of Memphis.* Memphis, TN: Memphis State University Press, 1979.

Vedder, O.F. *History of the City of Memphis and Shelby County.* Vol. 2. Syracuse, NY: D. Mason and Company, 1888.

Walk, Joe. *Memphis Executive and Legislative Government.* Memphis, Tennessee, 1996.

Wrenn, Lynette Boney. *Crisis and Commission Government in Memphis: Elite Rule in Gilded Age City.* Knoxville: University of Tennessee Press, 1998.

DISSERTATIONS

Caplinger, Christopher. "Conflict and Community: Racial Segregation in a New South City, 1860–1914." PhD diss., Vanderbilt University, 2003.

Palmer, Charles Steven. "'I'm Tired of Feeling Like a Garbage Man': Labor, Politics, Business, and the 1978 Memphis Fire and Police Strikes." PhD diss., University of Mississippi, 2002.

GOVERNMENT DOCUMENTS

City of Memphis. Minutes of City Council, Board of Health, Etc., February 12 and May 6, 1874.

————. Minutes of the Board of Mayor and Aldermen, August 7, 1860.

————. Minutes of the Board of Mayor and Aldermen, July 28, 1862.

————. Minutes of the Board of Mayor and Aldermen, September 18, October 4 and November 3, 1873.

City Planning Commission and Harland Bartholomew. *A Comprehensive City Plan, Memphis, Tennessee.* Memphis, Tennessee, 1924.

Digest of the Charter and Ordinances of the City of Memphis, 1876. Memphis, Tennessee, 1876.

Municipal Reference Library. *Summary of Minutes of City Council, Board of Health, etc. City of Memphis, Part I: 1826–1855.* Memphis, Tennessee, n.d.

Spencer-Sturla Company v. City of Memphis. Supreme Court of Tennessee at Nashville, April 1926. Memphis, TN: Memphis Linotype Printing Company, 1926.

State of Tennessee. *Amendment to Charter of the City of Memphis.* Nashville: Tennessee General Assembly, 1905.

United States Congress, House Select Committee on the Memphis Riots. *Memphis Riots and Massacres*, Washington, D.C., 1866.

MANUSCRIPT COLLECTIONS

Walter Chandler Papers, Memphis Public Library and Information Center, Memphis, Tennessee.

E.H. Crump Collection, Memphis Public Library and Information Center, Memphis, Tennessee.

Frank Holloman Collection, Memphis Public Library and Information Center, Memphis, Tennessee.

Maxine Smith/NAACP Collection, Memphis Public Library and Information Center, Memphis, Tennessee.

INDEX

About the Author

G. Wayne Dowdy is the senior manager of the Memphis Public Library and Information Center's history department and Memphis and Shelby County Room. He holds a master's degree in history from the University of Arkansas and is a certified archives manager. He is the author of *Hidden History of Memphis*, *Mayor Crump Don't Like It: Machine Politics in Memphis* and *Crusades for Freedom: Memphis and the Political Transformation of the American South*. Dowdy has served as a consultant for the NBC-TV series *Who Do You Think You Are?* and has appeared in the documentaries *Overton Park: A Century of Change, Memphis Memoirs: Downtown* and *Citizens Not Subjects: Reawakening Democracy in Memphis*.

Visit us at
www.historypress.net